IMAGES
of America

CORTLAND

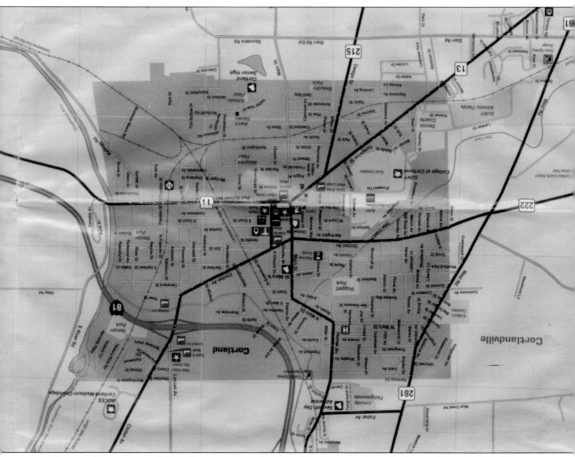

The city's center on Main Street, identified by the cluster of symbols on the map, is the same location where activities have been focused for more than 200 years. (Copyright 1999, Progressive Printing, Inc., Bloomingdale, Illinois.)

IMAGES
of America

CORTLAND

Mary Ann Kane

ARCADIA
PUBLISHING

Published by Arcadia Publishing
Charleston SC, Chicago IL, Portsmouth NH, San Francisco CA

Printed in the United States of America

Library of Congress Control Number: 2009941186

For all general information contact Arcadia Publishing at:
Telephone 843-853-2070
Fax 843-853-0044
E-mail sales@arcadiapublishing.com
For customer service and orders:
Toll-Free 1-888-313-2665

Visit us on the Internet at www.arcadiapublishing.com

*To my father, for his love of Cortland and of history, and to my mother,
for the shared enjoyment of all those genealogy and antique excursions.*

CONTENTS

ACKNOWLEDGMENTS

Founded in 1925, the Cortland County Historical Society has compiled an outstanding collection of artifacts and archives rich in research material. Housed in the courthouse and Cortland Free Library in the years leading to the mid-1960s, a place of its own was realized with the gift of the large Italianate home of the Suggett family from their great grandson. Hundreds of volunteers and the small paid staff have been the front line in providing help and education to the public in the Suggett House Museum and in the Kellogg Memorial Research Center, which is located in a climate-controlled wing attached to the museum. The majority of the photographs in *Cortland* are from the society, with additional images from the author. Research at the society is the source of material in the captions. Joan Siedenburg's dedication and financial support for 40 years has encouraged professionalism; collections manager Anita Wright's 35-plus-year career has overseen the county's treasures; volunteer Betty Bonawitz has researched for hundreds of genealogists; and the members of the volunteer group Cutters and Pasters have updated the research center's holdings each week. These are only four of the reasons for the society's respected position in the community. Unless otherwise noted, all images are courtesy of the Cortland County Historical Society.

INTRODUCTION

The city of Cortland sprawls across seven valleys with steep hills encircling it and a knob of a hill in its heart, all providing striking vistas. Cortland bears its county's name, is the county seat, and was once considered the center of New York state. It has been known as the "Crown City" and "Huskietown, USA."

In 1804, four families lived in what was referred to as Homer's "lower village." One of those settlers was Jonathan Hubbard who, with Moses Hopkins, arrived here in 1794 and owned much of the land that became the hub of the village of Cortland. Settlement of central New York was slowed by the 1783 creation of the Military Tract by a cash-strapped state government as a means to entice enlistments and pay debts to its soldiers. The surveyors' results, completed in 1790, did not invoke a land rush. Few settlers of the original land grants chose to live here. New Englanders, primarily from Massachusetts and Connecticut, came directly or from where they had settled earlier along the Hudson and Mohawk Rivers.

When Cortland as a county was separated from Onandaga County in 1808, a hot contest ensued as to the location of the coveted courthouse. Homer, McGrawville, and Port Watson were the obvious contenders, but Jonathan Hubbard donated land on the hill between today's Monroe Heights and Pleasant Street, Samuel Ingalls promised $1,000 towards construction, and Hubbard personally visited, at some distance, the commissioners who would make the decision. The effort would be rewarded by economic opportunities.

Small shops, general stores, law offices, and taverns were active. Asheries, tanneries, sawmills, gristmills, carding mills, potteries, and cooperages provided jobs in addition to those that already existed for agriculture. Evidence of success could be seen in the homes of William and Roswell Randall. They were built amid impressively landscaped grounds on Main Street in the 1820s. Jonathan Hubbard could look up at the courthouse on the hill from the first frame house built in town, at what eventually became the corner of Main and Court Streets. Local prosperity resulted in the 1838 replacement of the plain wooden courthouse with a brick Greek Revival building with massive columns at the northeast corner of Chapel Street (Church Street) and Court Street. The churches of several denominations were the courthouse's neighbors. All of these churches except the Unitarian "Old Cobblestone Church" have been rebuilt. Cortland village's population had grown to about 1,200 at the time of the Irish immigration. By 1850, ten percent of its people were Ireland-born.

Education took place in the one-room schoolhouses. The Cortland Academy was built on acreage on Chapel Street. In 1869, the New York State Normal School in Cortland began to evolve on land formerly owned by the academy. It provided students with an opportunity to become teachers, and an elementary school for practicing teaching was part of the complex. It faced an uncertain future in 1919, when the entire school was destroyed by fire. The state rebuilt the school on the top of Court Street hill; it opened in 1923. The school's growth in buildings and degrees since World War II has made the State University of New York at Cortland an important economic contributor.

When canals began to compete with river and turnpike transportation, an alternate distribution method was sought. By the mid-1850s, when the route of the Syracuse and Binghamton Railroad passed through Cortland, 1.5 million pounds of butter and $220,000 worth of cattle would be annually exported through its freight yards. Large-scale industrialization became the norm as factories grew alongside the tracks for more than 60 years. The Cortland Wagon Company was one of several large producers of wheeled vehicles and varieties of sleighs. It was the first native business to develop a national sales organization, ship its products to Australia and New Zealand prior to the Panama Canal shortcut, and open a plant in Canada to avoid paying excise taxes.

The move to become a city officially began in the fall of 1899. Taxes were causing major controversy. The village was paying 82 percent of the taxes of the Town of Cortlandville, of which it was a part. It also contributed one-fifth of the total county taxes, but had only one-fifteenth representation on the board of supervisors. The village charter limited village trustees when they attempted public works projects, such as paving or sewer installation. To spend $5,000 or more, a town meeting had to be called, and the resulting vote was the determiner of what would or would not be accomplished. Additionally, Cortland was a "dry" community, and a New York State law allowed a newly chartered city to sell liquor under license rather than through a local option. The leading player in the resulting drama, Samuel Holden, was elected village president by one vote, securing the presentation of a city charter to the state legislature, which was signed by Gov. Theodore Roosevelt in March 1900.

Locally owned companies with national and international reputations provided generally secure employment for the population and for the Italian and Ukrainian immigrants of the new century, even during the Great Depression. During World War II, local industries converted to producing materials for the war effort, but following the peace, retooling and foreign competition saw the closure or movement elsewhere of long-standing businesses.

Cortland County was known for generations for its skilled labor, abundant pure water, and a transportation system of rails and highways, which could get people anything or anywhere quickly. But those qualities seemed not as important as local government, the chamber of commerce, and state and federal representatives scoured the country to bring new opportunities to Cortland. Large companies came and either could not adapt to changes in their own industries or remained only long enough to receive property tax benefits for coming here. Opportunities have come but not as expected. Not only did the size of the Cortland college campus grow, but its student body also grew to slightly under 8,000. The Essex Structural Steel Company did not have the 1,500 employees Wickwire had, but it moved from an old Brewer location into a new building. Two Ithaca firms expanded into Cortland. Small companies were taking a stab at success. Tourism has some interesting possibilities for which new hotels are grateful.

Currently, new growth in most cases is in the town of Cortlandville. Jobs are provided and county taxes paid, but no property taxes flow to the city. The city is boxed in by old boundaries, so chapter six speaks of some places on the edge of the city. James Yaman owned land on which he wanted to build many homes, and so he wanted this land outside the city to be annexed. The city received a beautiful park as a benefit for reacting favorably to that idea. And in a community where the New York Jets chose to spend part of their 2009 summer training camp on Cortland's college campus, anything can happen! Cortland is a survivor and will continue to be. People can enjoy the past if they support their local museums and take care of their buildings sited as historically significant by the federal and state agencies. At the same time, people can be proactive in Cortland by participating in organizations and on committees that will see the city's future as a place in which families want to live and work.

One

A GROWING VILLAGE

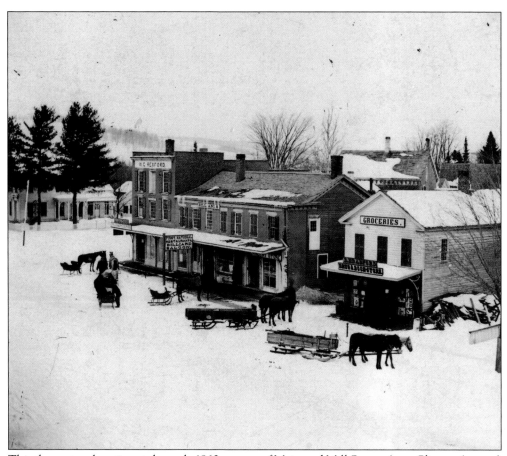

This three-story location at the early 1860s corner of Main and Mill Streets (now Clinton Avenue) became part of the Dexter House as it developed where the First National Restaurant stood. H. E. Ford was a blacksmith handy for the patrons staying at the nearby hotel.

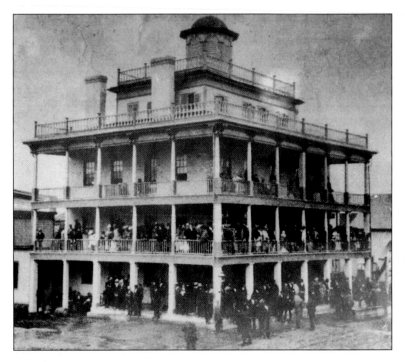

Two hotels resembling giant wedding cakes bracketed Main Street at Mill Street and at Port Watson Street. The Eagle Hotel of the Randalls was built in 1818, while Danforth Merrick's Cortland House rose in 1829. It is unknown what the inspiration was for this crowd at the Cortland House. The Eagle was lost to fire in 1862, and the Cortland House burned in 1883.

This photograph of the New York State Normal School in Cortland was likely snapped from the roof of the second courthouse, located on the northeast corner of today's Court and Church Streets. Constructed in 1869, the brick school stretched from Church to Greenbush Streets. Destroyed by fire in February 1919, there were no lives lost, and the library's contents survived.

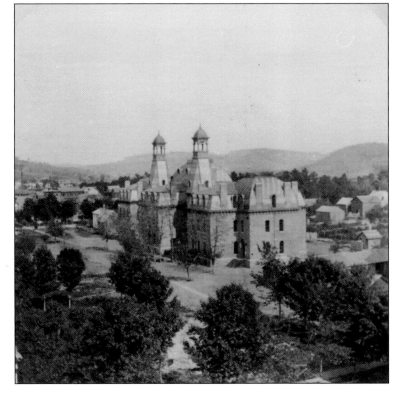

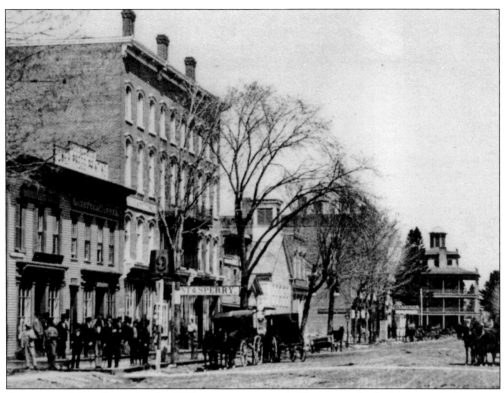

Activity on Main Street in the 1870s was pronounced. The west side, looking north, begins at West Court Street with Power Press Printing advertised at the *Gazette and Banner*'s offices and Kent and Sperry's clothing in the Messinger Hall block. The building resembling a white church is the firehouse, replaced in 1875 by Firemen's Hall. The Cortland House is shown at the end of the street.

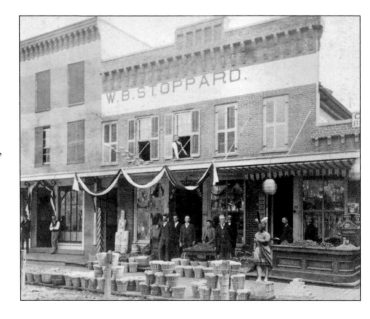

Methods for numbering structures on Main Street changed as its dimensions did, so this Main Street scene, including Stoppard's grocery with produce displayed on the sidewalk, is not exactly known. To its left is possibly an extended barber pole indicating a barbershop. To the right, the wooden Native American statue symbolizes a tobacconist. Decorations could indicate the Fourth of July.

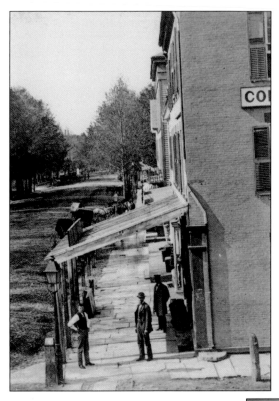

Main Street was growing, and so were some community problems. There were rules against littering the cut-stone sidewalks and the roads. The wooden canopy may have helped keep customers dry, but in the winter, they presented a hazard to horses and transportation modes as snow and ice cascaded from them. An 1884 ordinance established a $5-per-day fine for wooden canopies extending from the building to the street.

The village did not lack colorful personalities in the 1870s. Noah Parsons (in top hat) spent nine years in the west searching for gold and may have found some with his clothes washer invention. Traveling west in a covered wagon, he demonstrated placing clothes on the roller and applying pressure on a pedal while moving a rubbing board by hand. His patent was dated in 1873.

In 1876, there were $1 shares sold to raise $5,000 to erect a fitting memorial to those from the county who had fought in the Civil War. Veterans were impressed by a monument in New York City. An 8.5-foot-tall, 1,800-pound bronze statue was commissioned to stand on a granite shaft. The statue is posed as a young volunteer on picket duty and overlooks Court Street from Church Street.

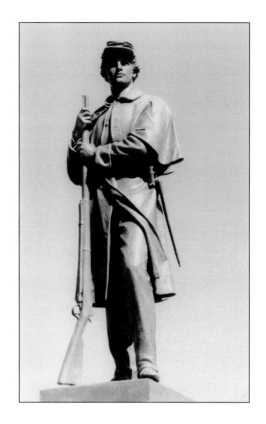

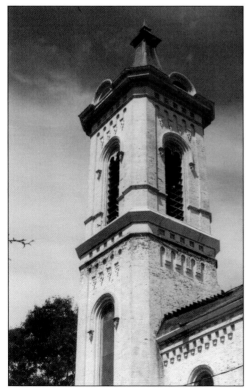

Jonathan Hubbard was important to the introduction of the Methodist religion to the village. The Methodist church of 1823 was the first for Cortland and was built through the barter system with no debt at its finish. It was replaced in the late 1860s on the same plot on Church Street. The church, with its nearly 100-foot-high distinctive steeple, was torn down in 1998 and replaced by a modern building in Cortlandville.

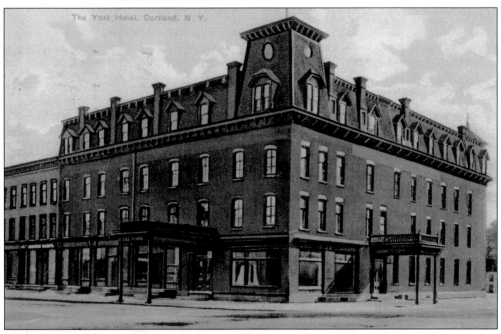

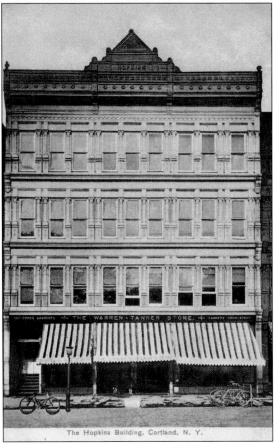

The Randall's Eagle Hotel at Main and Port Watson Streets opened in 1818 and was fated to burn in 1862. The Messenger House was in its stead in 1864 with three floors, boosted to four as its commercial business increased. Ropes from upper floors lowered furniture during a 1910 blaze. In 1936, for $22,000, it was purchased and replaced by a gas station.

Warren and Tanner had a long dry goods career, beginning at 47 Main Street in 1872, then moving into the new Schermerhorn Building in 1880, and finally, in 1891, moving into a greatly expanded space in the new Hopkins block at 83–85 Main Street. Making change for customers was greatly improved by a cash carrier system, which J. C. Penney later used when it operated there. These dry goods businesses ceased in 1961.

Students at the normal training school pose on its lawn. Future teachers were the primary emphasis at the normal, but to be proficient, they needed to practice skills they had learned. The training school was the practice site. Jennie Benton, second on the left sitting in a chair, was the founder of the Cortland County Historical Society about 40 years later.

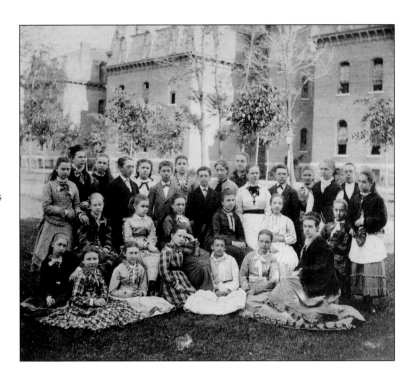

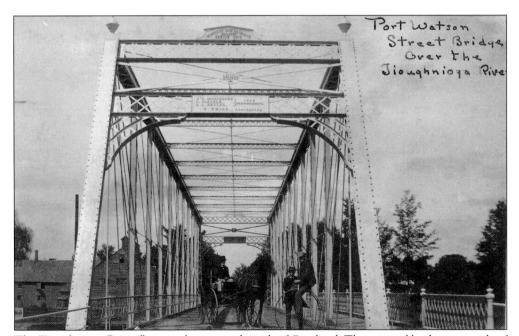

The Tioughnioga River flows to the east and north of Cortland. The original bridge was made of rope. This bridge by the Wrought Iron Bridge Company of Canton, Ohio, is decidedly not that! Installed in 1886, it has been replaced at least twice. The dark building to the left on the shore was the Kinney Tannery. The tannery was recycled into an attractive home.

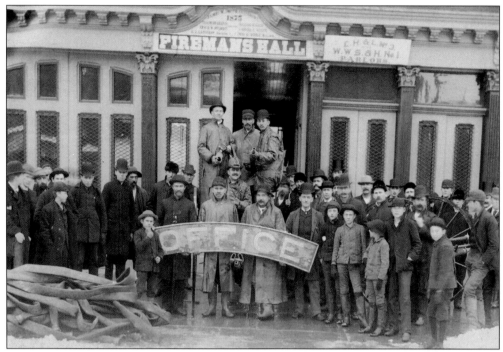

Fireman's Hall, which is still on Main Street, is shown on December 6, 1888, following the fire at Cortland's largest industry, the Cortland Wagon Company. The night watchman may or may not have made his rounds, and the new sprinkler system did not work. Rebuilding began immediately. At least the office sign was saved.

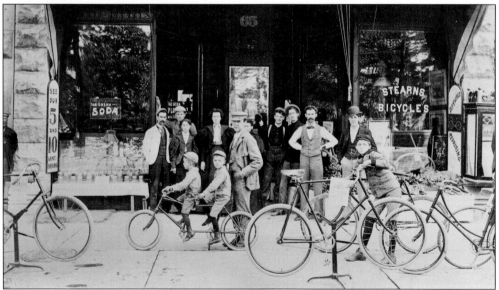

G. Fred Beaudry Sr. initiated a plan on his arrival in Cortland that would help to support his entrepreneurial efforts. He purchased 73 Main Street and in 1885 constructed a three-story building with a metal cornice, a limestone name panel, colored glass transoms, and terra-cotta decorations, which are still admired. His stationery and bicycle store held the village's first soda water fountain, 2.5 feet long.

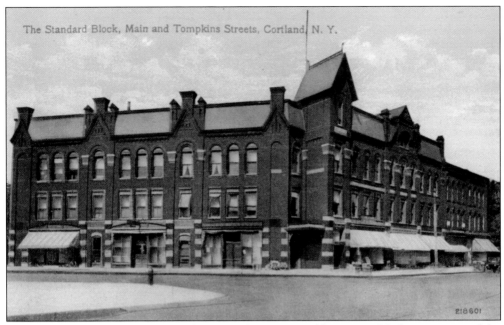

The *Cortland Standard* began publishing as a four-page weekly in 1867. Under variations of the name, it grew in pages at different addresses until 1883, when it moved into its own building at Main and Tompkins Streets. Its third floor was occupied by a number of organizations, and businesses sold paint and groceries in shops on the first floor. The newspaper became a semi-weekly and then, in 1892, a daily.

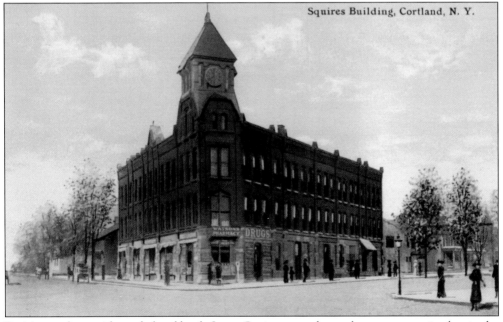

Retiring as the president of a local bank, James Squires turned to real estate, promoting lots in the southwest portion of the village, close to the Lehigh Valley Railroad yards and a variety of small factories. Acquiring the old Eagle Store property, he built a four-story brick commercial building in 1883 around the store and opposite of the new Cortland Standard block.

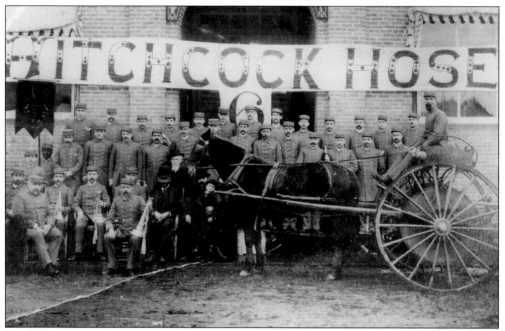

The Hitchcock Hose Company No. 6 was formed in 1888 to protect the huge Hitchcock Carriage Company, and nearly all its members were employees. Its apparatus was a two-wheeled cart drawn by Billy, a black horse, the first for any of the volunteer companies. The civilian with the white beard was Dr. F. O. Hyatt, who lost 150 valuable paintings in a Main Street fire in 1884.

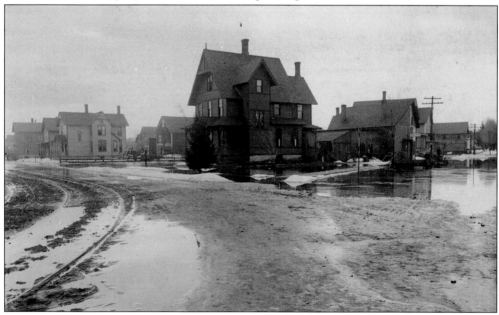

The horse car tracks are following today's Route 11 through the mud while water accumulates between Brown Avenue (formerly Doubleday Street) and the intersection of North Main Street and Homer Avenue. Dry and Otter Creeks are the miscreants as snow melts in the 1890s. There was a bridge crossing each waterway to the left, but they had no damming capability. Water now flows under Homer Avenue and North Main Street.

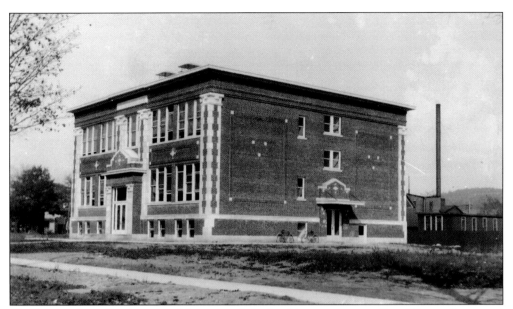

Children in the village's east end first attended school in one room on Port Watson Street and then in an 1893 two-story wooden building on Pomeroy Street where St. Anthony's Church stands. In 1912, for $17,500, a new school was built across the street, and it was built onto in 1950. Grace Dowd, who spoke Italian, was hired at its opening as a teacher of English as a second language.

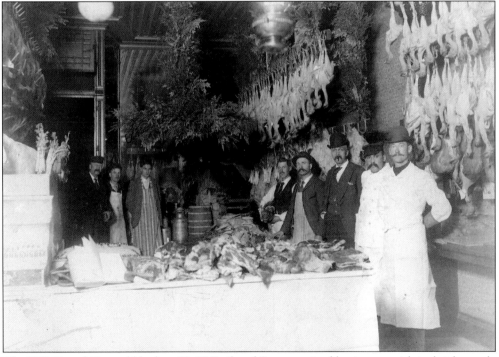

The 1887 Grand Central block at 13–29 Railroad Street enticed businesses with its brick arcade and recessed entrances. C. F. Thompson sold groceries at 16 and 40 Main Street prior to 1887 and was located at 21 Main Street from 1891 to 1904. He was prominent in business and civic affairs. The picture dates to Thanksgiving 1894. Thompson is third from the right.

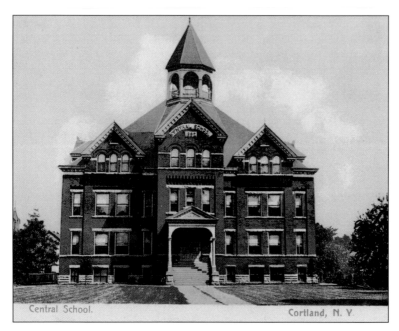

Central School. Cortland, N. Y.

The Cortland Central School of 1893 was built from 575,000 bricks and cost $21,415. Pupils in kindergarten through grade 12 entered in the rear. A speaker tube connected each classroom to the superintendent's office. There was wool under the maple floors to deaden the sound, and a ventilating system exchanged air every 30 minutes.

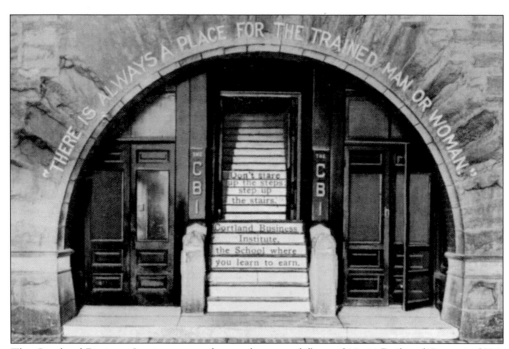

The Cortland Business Institute moved onto the second floor of 12–14 Railroad Street in 1896, providing a two-year course of study leading to a diploma in either bookkeeping, cashiering, general business, or stenography (which required 150 words per minute typing). The institute continued graduations into the early 1950s.

The village's first hospital was in a house on the corner of Clayton Avenue and Hill Street housing six patients. For a time, one woman served as matron, nurse, and housekeeper with a boy to tend the furnace and the walk. It had no running water or telephone, but it trained nurses, sending them to the homes of the ill for a fee. These fees supported the hospital.

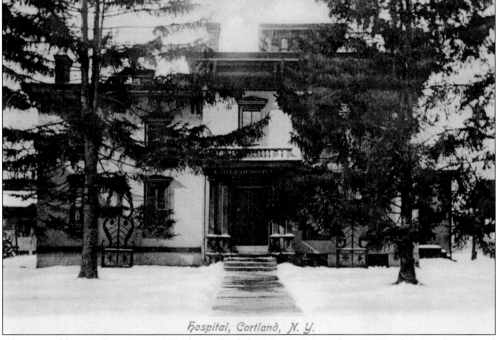

Hospital, Cortland, N. Y.

The second hospital was in an 1834 home built by Martin Merrick at 84 North Main Street and purchased for $6,000 in 1895. There were two patient rooms and two wards, nurses' training continued, and a new wing was added. Dr. C. D. VerNooy bought the property in 1931 and operated it as a private sanitarium. That was closed in 1951, but the building has continued with space for doctors.

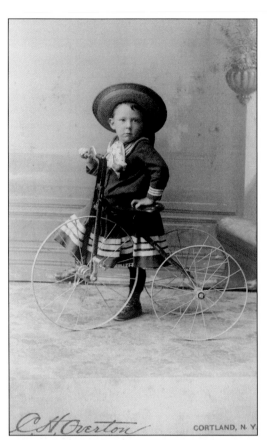

Norman Crombie holds fast to the tricycle with a look that would stop traffic. Norman, who lived at 59 North Main Street next to St. Mary's of the Vale Church, is dressed in the style considered appropriate for his age. If he chose to ride the prop—village law did not allow riding on sidewalks—he would need a lantern at night and a warning noisemaker at any time.

Cortland's Opera House opened in 1885 and was located on Groton Avenue next to the Cortland House. Built at a cost of $43,000, it seated 1,000 people. Its programs' stars included the greats of the European and American theaters, and eventually, as the Cortland Theater, it hosted the best of vaudeville and the cinema. Bill Dillon's brothers added a skating rink.

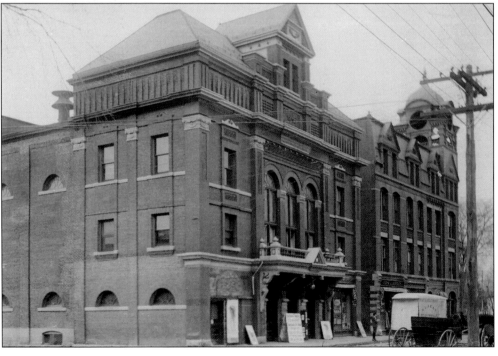

Alexander Mahan produced incredible shows at the Opera House from 1875 to 1900. The audience is not viewed here—this is the assemblage of the chorus and the orchestra. For one production, the stage was extended to accommodate 350 singers.

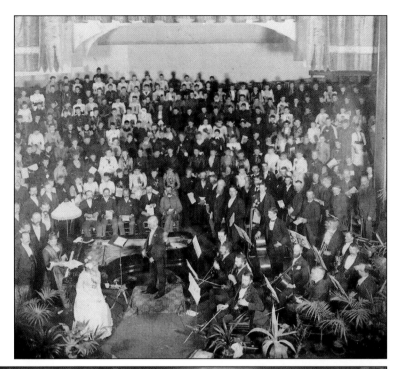

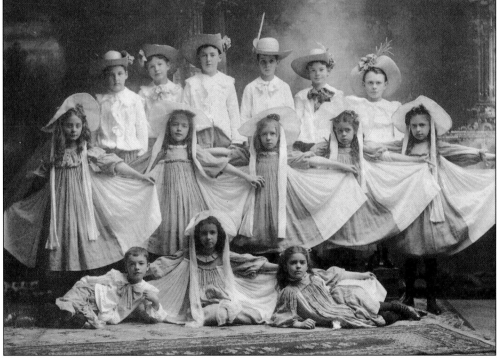

Neither John Phillip Sousa nor Madame Melba are pictured here. Village children are handsomely costumed for one of Mahan's last shows. Pictured in the first row are, from left to right, G. Fred and Ida Beaudry, who were part of the family's professional trick bicycle riders. Smiling broadly with a neck bow that sets him off from the other boys is Norman Crombie.

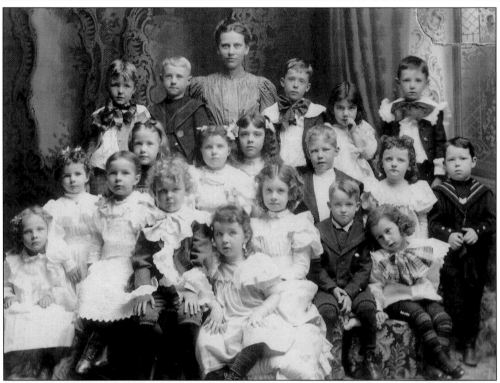

Long before preschool and kindergarten were defined as they are today, some families could afford to provide that education in private circumstances. This group is believed to be in Emily Ormsby's Court Street school, held in her home. Glen Wolcott, of 54 Maple Avenue, stands to the right of the teacher around 1899. The little boy in front with the plaid bow appears to be napping.

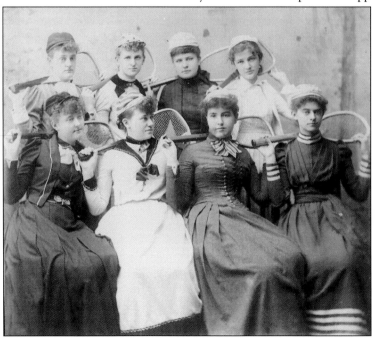

Lawn tennis was introduced in the United States in 1873, and its popularity spread quickly to owners of large yards. Dressed for the game, these young women are age 20 to 21 in the early 1890s. Pictured are, from left to right, (first row) Carrie Cardo, Grace Duffey, Alice King, and Bessie Hull; (second row) Anna Cardo, Edith Watrous, May Hale, and Annie Putnam.

Brogden's, at 77 Main Street, may have been a drugstore, but it was the preferred stop for chocolate sundaes from 1894 to 1931. On the left, opposite the awning, is one of the gargoyles on the front of the Beaudry Block, the same building where the prominent head of a Native American views the street's activities even now.

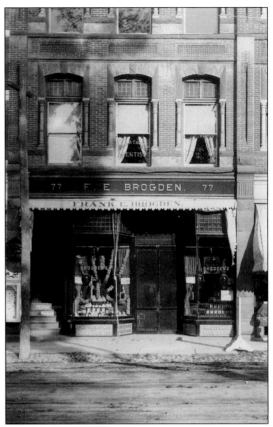

This three-story building at 51–55 Main Street not only housed the National Bank until 1936, when it merged with the Second National Bank to form the First National Bank, but also included a cigar maker, a lawyer, a broker who dealt cotton, a coal company office, a druggist who sold cookies and fitted trusses, and a boot and shoe store. Note the wired pole, fountain, hydrant, and the site of Meldrim's paint store.

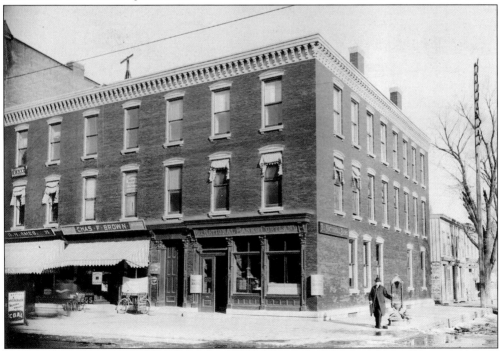

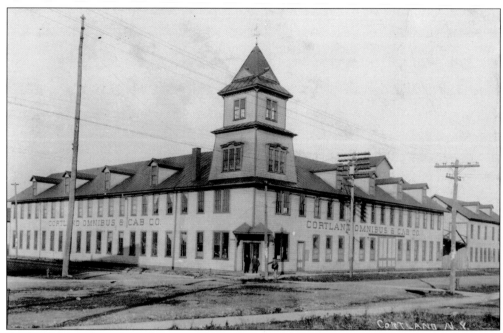

As 1900 approaches, the end is near for Ellis Cortland Omnibus and Cab Company. This is one of the largest exclusive builders of horse-drawn buses, wagonettes, cabs, and hotel coaches in the country, but the gasoline engine is knocking at the curb. In 1912, Brockway Motor Trucks' three-cylinder, chain-driven trucks would be manufactured here.

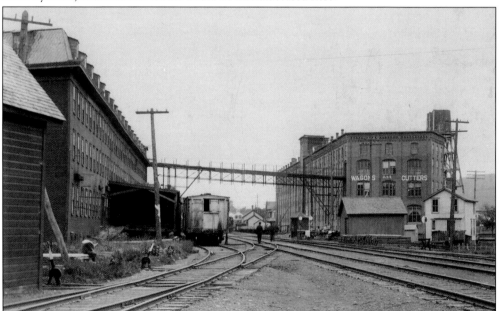

Keator and Welles held out in the bankrupt Hitchcock Carriage Company, which spanned the railroad tracks, until shortly after the beginning of the 20th century. Future tenants included Smith Corona storage and Durkee's bakery, which removed the top floors and painted the one building white. The site is now home to a soccer field and is the former location of the East End Community Center.

Two

THROUGH A CITY'S
TEENAGE YEARS

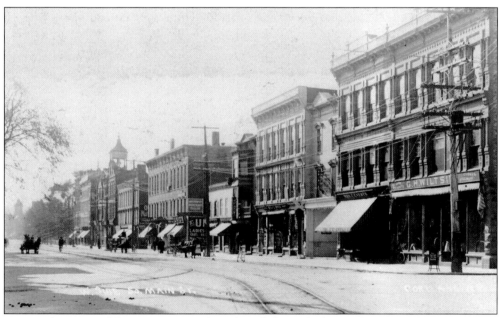

G. H. Wiltsie arrived from Vermont and purchased Shepard's dry goods store in the 1897 Samson Block in 1902. Next-door was Mrs. Everts' Millinery. At 10 Main Street was an A&P Grocery, and at 16–20 was the Cortland Foundry and Machine Company. Cloth awnings were permitted if retractable. Business looked good on Main Street's west side.

Samual Holden was a prisoner of war during the Civil War and served in the 157th New York Volunteers. He was a coal dealer, whose involvement in politics saw him become the last president of the village of Cortland in 1899 and the city of Cortland's first mayor in 1900. Cortland was 23rd in wealth and resources in the state.

The Cortland Savings Bank was first on the second floor of the Randall Bank (southeast corner of Main and Court Streets) and then moved to the Keator Block at Main and Port Watson Streets. A lawyer, who was also the new city clerk, then rearranged his second-floor office there to make a headquarters for the mayor and a meeting place for the common council.

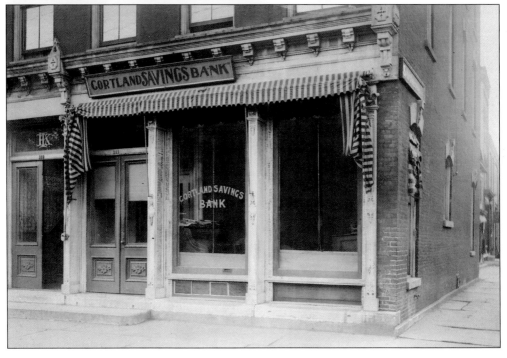

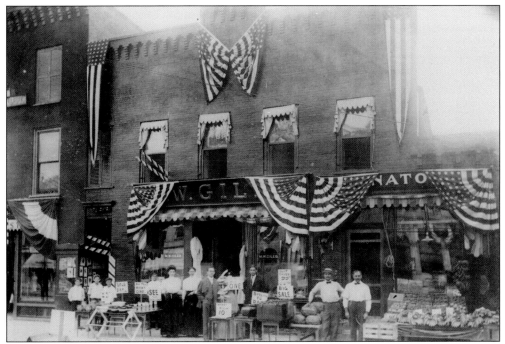

Maurice Giles's department store at 37 Main Street sold a full range of products for ladies and the home. The store put crockery and women's hats on sale along with 99¢ suitcases. Arriving only recently from Italy, Antonio Natoli sold fruits and vegetables in the next store. Watermelon and bananas were in season.

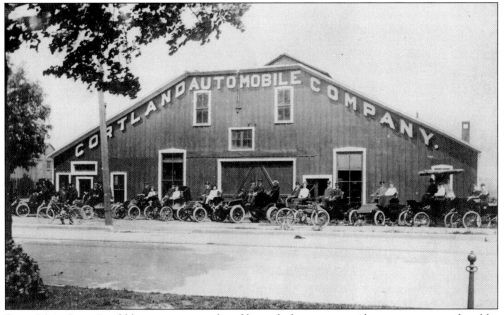

Since Main Street's cobblestones were replaced by asphalt, motorcar rides were more comfortable. Horses left stains on the new pavement, so the city had men in white suits sweeping it. These automobile owners and at least one motorcyclist (left front) have grouped for a Sunday afternoon drive. Note the canopy over the two-seater on the right.

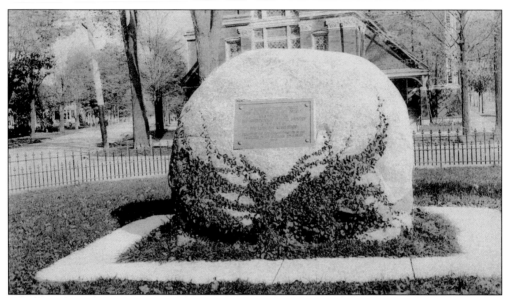

The Daughters of the American Revolution selected a 26-ton quartz schist boulder from Kinney Gulf Road as a monument to settlers in the county who had served in that war. On its route to a flatiron-shaped park between Elm Street and Clinton Avenue, it rolled into Dry Creek. Lack of responders to inquiries about veterans limited the number of veterans listed on the monument to 107 when it was dedicated in 1906.

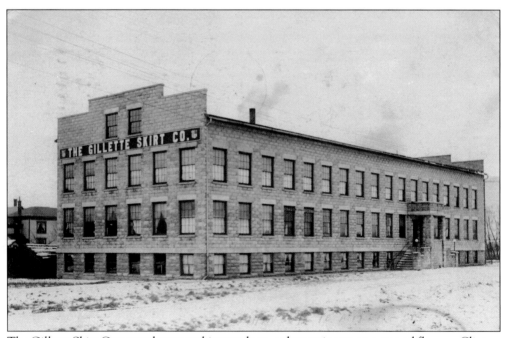

The Gillette Skirt Company began making made-to-order petticoats on a second floor on Clinton Avenue near Main Street in 1896 and then moved to Homer Avenue, where it was soon burned out. The company then constructed the city's first concrete block building. Both Chester Gillette, nephew of the owner, and Grace Brown, whom Chester murdered in 1906, worked here.

This would have to be a teenage girl's room. There are decorative pillows on the floor, couch, and bed, a mandolin, hourglass figure pictures for weight loss inspiration, photographs of several gentlemen, and college banners but few books in this photograph. Perhaps all were a normal school girl's collection.

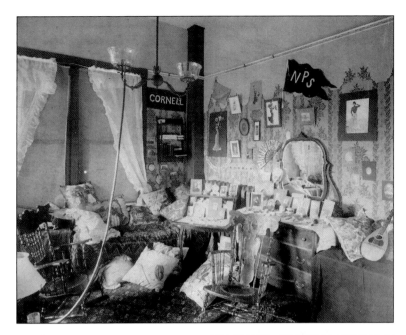

For all the modern construction of the Central School, by 1901, it lacked space, and teachers could expect 40 students in each class. Vacant rooms on Main Street were rented for the overflow from classes held in school hallways. Support for an enlargement was passed by only a handful of votes. In 1906, fraternities such as Kappa Zeta met at the school.

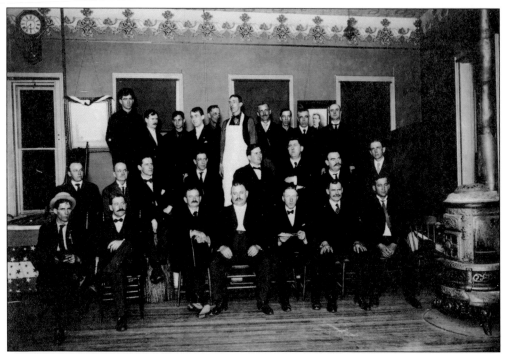

One hundred years ago, men formed organizations for social purposes, business connections, and inexpensive life insurance plans paid for through their dues. Meeting space was usually rented on Main Street's upper floors. The Improved Order of Red Men, Pecos Tribe 357's sachem led his members while sitting on a tree stump (third from left in the second row).

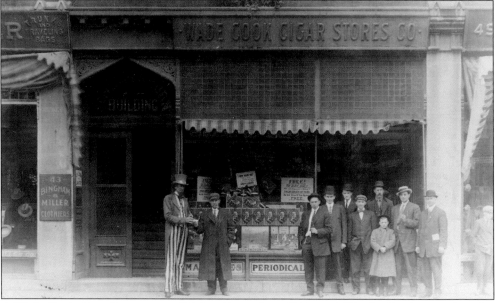

A Wade Cook Cigar Store was at 47 Main Street from 1910 until Charles Sanders purchased it in 1914. Uncle Sam helps the store celebrate "free for one day only" specials. Photographs at this time were generally taken outside, as the interior light of stores was not strong enough and there was little room among the merchandise for people to pose.

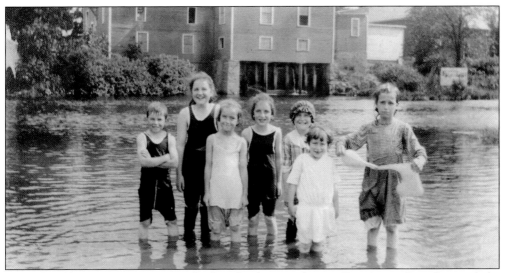

Oh, to be able to swim in one's own backyard! The Tioughnioga River's west branch provided a playground for the east side's neighborhood children. From Clinton Avenue came the McMahans and the McEvoys to splash behind Jonathan Hubbard's mill in the summer and to ice-skate in the cove in the winter.

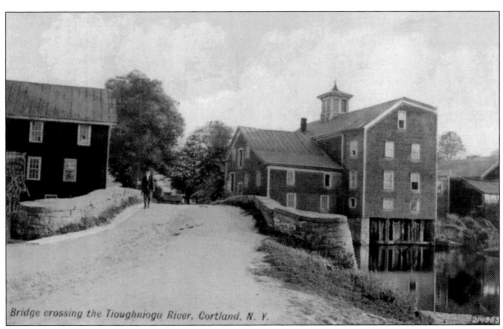

Bridge crossing the Tioughnioga River, Cortland, N. Y.

This bridge crossed the Tioughnioga River in 1854 on a busy route north from Mill Street, now Clinton Avenue, to Truxton. The mill on the left produced firkins and later cider, where one brought a glass jug and it would be filled. The mill on the right was primarily a feed mill, owned at times by the Hubbards, Mudges, Wickwires, and Homer Jones. The bridge was first replaced in 1948 for $175,000.

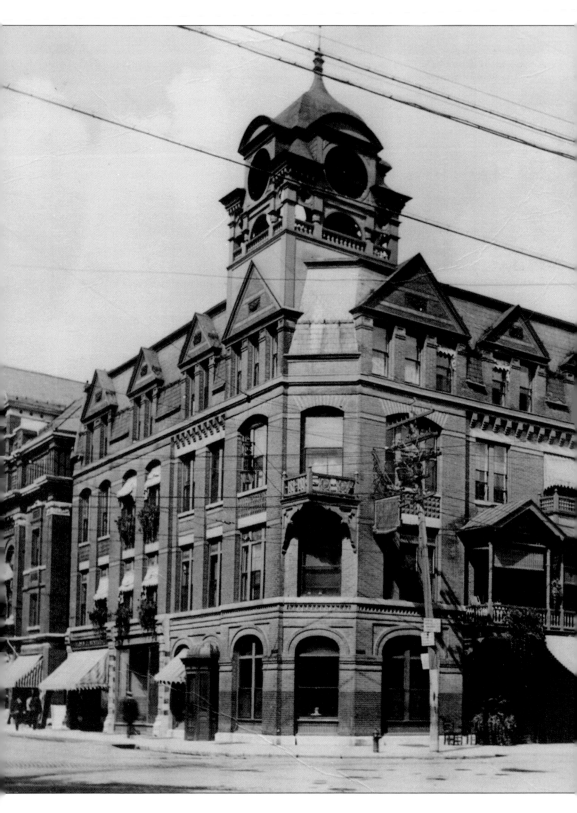

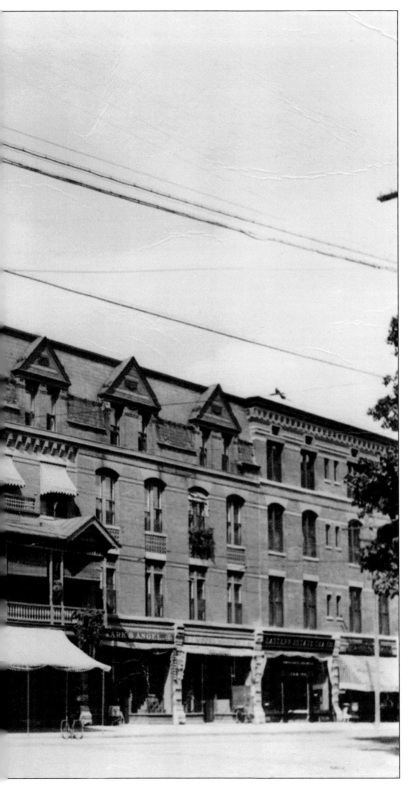

Delos Bauder purchased the Cortland House in 1862 for $15,000. When it was destroyed by fire in 1883, he set out at once to rebuild. The village had an 1895 ordinance that no wooden buildings could be built on Main Street or within 300 feet of it. Before the law, Bauder responded by building a magnificent, four-story brick hotel. Business was helped by the construction of the Opera House next door on Groton Avenue at this same time in 1884. There were opportunities for shops on both streets. Instead of holding wakes for the deceased at home, one could do so on the second floor. Dining was also on that level. In 1910, the hotel was enlarged by 40 rooms and 20 private baths and was considered as close to fireproof as one could be.

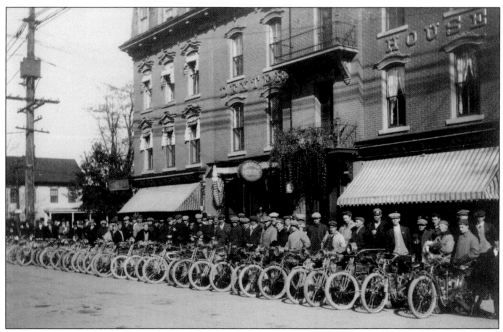

The different window tops give away the fact that these are two buildings with a mansard roof over both. The white house on the opposite corner of Clinton Avenue and Main Street was moved a few years later to Charles Street. Motorcycling was a sport of the early 20th century, with races run at the fair grounds for charity or for monetary prizes. Perhaps safety gear lacked relevance in 1910.

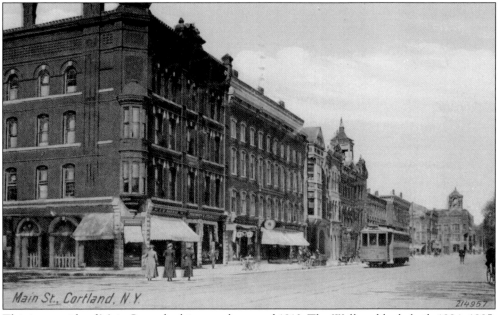

This is west side of Main Street looking north around 1910. The Wallace block, built 1884–1885, was home to a wallpaper manufacturer who also ran a stationery shop. The bays and top two floors were removed in 1968. Next to it is the Taylor Hall block. It was built in 1863–1864 and was lost in a 1960 fire; the upper floors were accessed by a stairway in the next building.

Construction on the 169-foot south steeple at the new St. Mary's Church was progressing. Pictured is the pastor, the athletic Rev. Patrick Donohoe, in black and smiling towards the camera. Three workmen are perched precariously. In 1911, Donohoe and John Harrison, a contractor, were inspecting the work on the 135-foot north steeple, with Harrison ahead and above the pastor. As Donohoe moved up, the scaffolding gave way, and Harrison fell to his death. A plaque memorializes Harrison at the Jewett Avenue entrance to the Main Street church. In the late 1950s, a fire set in the church was first seen by one of Harrison's daughters, who lived next door on Jewett Avenue. Heavy damage occurred in the two sacristies and in the back of the sanctuary, but her call to the fire department avoided a catastrophe. Firemen were answering a call in the Squires building at that time, which likely had been set as a distraction to increase the problem for the church.

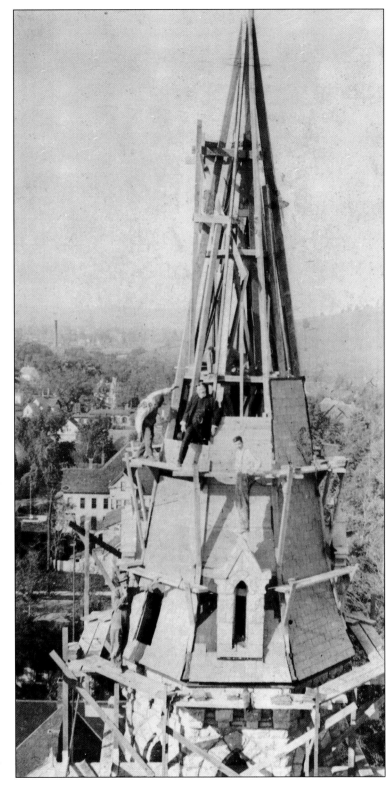

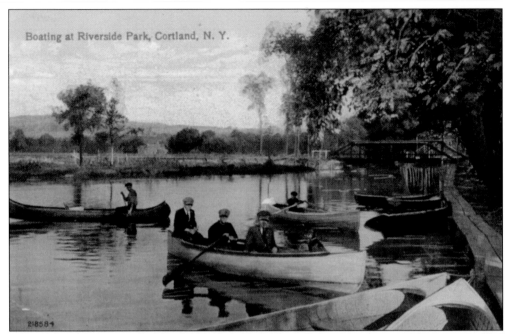

Boating at Riverside Park, Cortland, N. Y.

Riverside Park on the Tioughnioga River, a 10-minute walk from the center of the city, provided boats for a 2-mile trip north or 40 miles south to Binghamton. Gardens, gravel pathways, picnic tables, snacks, and children's swings were available, along with a 10,000-square-foot dance hall that became an IGA grocery and American Legion Hall and is now part of Selco.

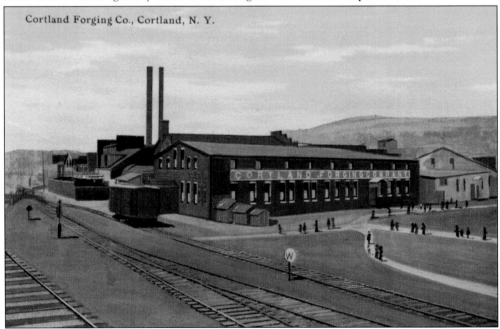

Cortland Forging Co., Cortland, N. Y.

The Cortland Forging Company was founded in 1889 and first produced top and body forgings for carriages. With the advent of automobiles, it began making forgings for Cadillac, Buick, Oakland, Chalmers, Hudson, and Ford. By 1917, it became an official part of the Brewer-Titchener Corporation. The site of the old smiths has been removed, and today it is associated with Campbell Chain.

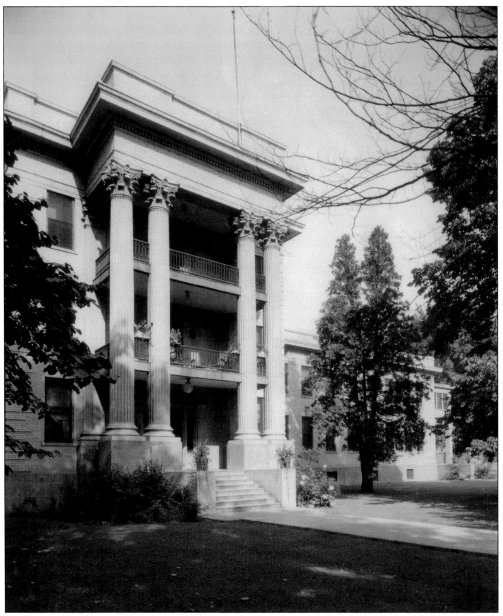

The generosity and foresight of Chester F. Wickwire was responsible for the construction of the Cortland Hospital, opening in 1911 at 134 Homer Avenue. George H. Wiltsie owned property he was willing to sell for $18,000 (its budget in 1986 was $18 million), and Wickwire donated $70,000 initially to insure that a first-rate facility would be constructed. By its opening, the Wickwires had contributed $95,000. The impressive entrance was modeled on one to the White House and faced east with the men's and women's wards extending north and south of it. The capitals of the pillars were removed when the 117-foot-wide buffer zone to the street became the site of its nursing and rehabilitation center. Other additions of new wings, a physicians building, and general expansions have erased the hospital's original architectural footprint. Names changed as well, from Cortland County Hospital, to Cortland Memorial Hospital, to the Cortland Regional Medical Center.

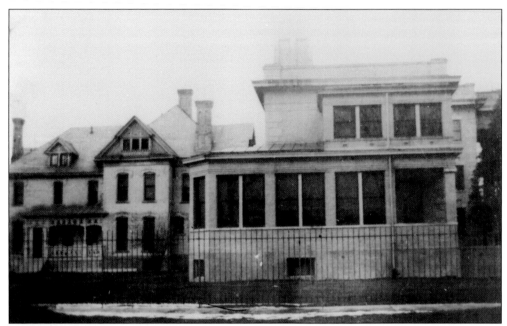

Is that a tumor extending from the back of the Cortland Hospital? Not quite. It is the Copeland-Fitz Boynton residence, which originally occupied the 5 acres now belonging to the hospital. The family's carriage barn was moved further back to house 500 chickens. The entrance corridor of the hospital extended into the house, where its basement held the hospital's kitchen.

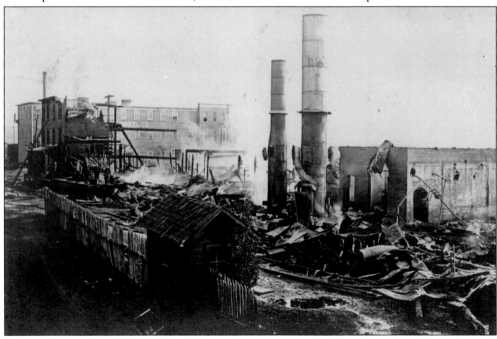

Will Cooper housed a junk shop at 3 Van Hoesen Street and a junk yard at Elm and North Franklin Streets. The shop suffered from flooding and was destroyed in 1913 by fire. Harold Clement restrained Fred Cooper from climbing to an upstairs office for records in the blazing structure. Cooper credited Clement for saving his life.

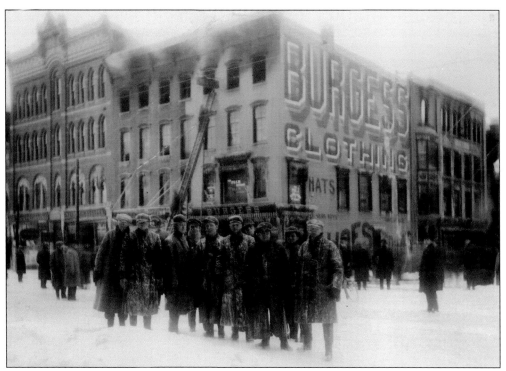

Archie Burgess opened the workingmen's clothing business in 1884 and was responsible for the idea of advertising barn signs made from the merchandise crates' wood. The February 1914 blaze began on the fourth floor of the neighboring Collins block in zero-degree weather. Records were saved, and mittens and gloves were given to the firemen.

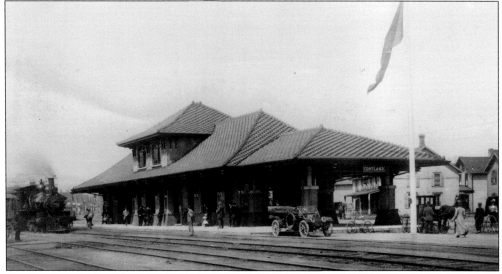

Cortland's second rail line opened in 1871 and by the mid-1910s had become the Lehigh Valley Railroad. A new station based on Mission Revival architecture was 155 feet long and 50 feet wide; it cost $27,519 and was located on Railway Avenue (now South Avenue). It still stands after the rail yards closed completely in 1971, although problems arose from the saloons established in it—broken windows, trash, water in the basement, destructive neighbors, and bar fights.

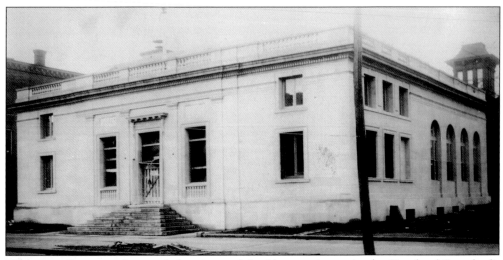

The post office moved around the city, and for 14 years, it was in the Cortland Standard's Tompkins Street side. In 1914, its own building was constructed on a Randall family's Main Street lawn. A mural installed later portrays Native American hunters with the title *Valley of the Seven Hills*, which lacks accuracy, as Cortland is the "City of the Seven Valleys." The post office was enlarged in 1941.

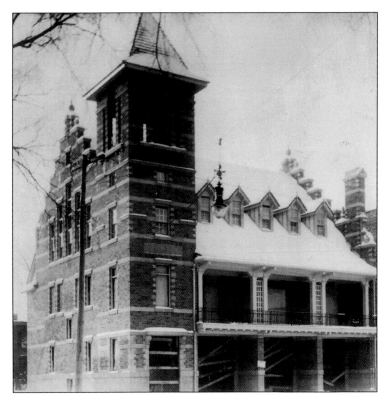

The village and city had been blessed with volunteer fire fighting companies that were located on Elm, Main and Church Streets when it was decided to incorporate them at a central station. Under construction at 21 Court Street in 1914, the station also began to hold paid firemen. Not built to house 21st-century trucks, it remains a remarkable piece of architecture while still providing the city's main source of fire protection.

The National White Brigade made a presentation at the Cortland Theater (former Opera House) in 1914 by forming a cross. Evangelist John A. Davis directed the presentation. Twenty-five Cortland girls attended the organization's camp at Bible School Park in Binghamton around 1914. The guns perhaps stood for the strength of their faith or for its advocacy.

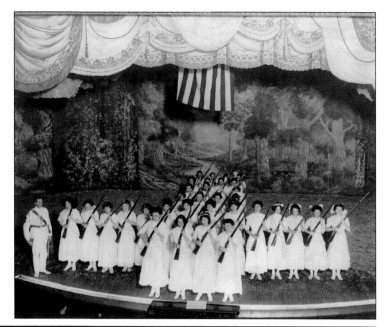

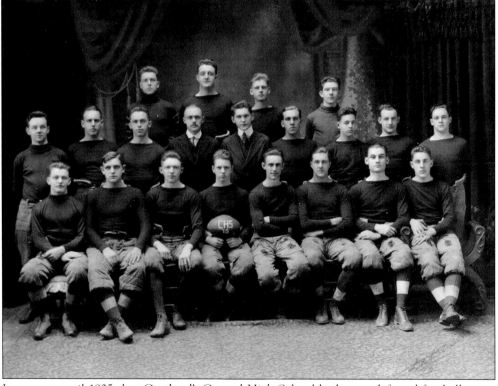

It was not until 1925 that Cortland's Central High School had an undefeated football team. Prof. Selah Northway, as coach, would not have known how many of his 1915 squad would be in a bigger game, World War I. Pictured front left, Eric Smith left school to enlist and returned to graduate in 1921. In the rear row, second from right, is Frank Fiske, later known for his advocacy for fellow veterans.

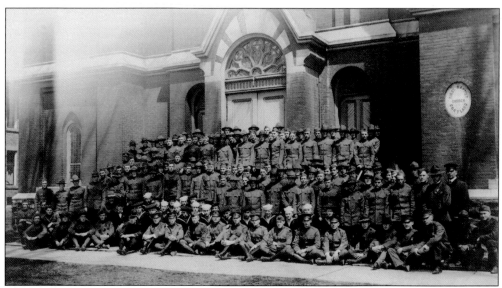

Cortland's great World War I victory parade was on May 4, 1919. Veterans were asked to don their uniforms and march. Twelve hundred Cortland men had served, and over 40 were killed. Not all had yet returned home, but 150 men marched. Elaborate floats, two regulation scout airplanes flying above, and wounded veterans riding in cars made for a heart-moving occasion.

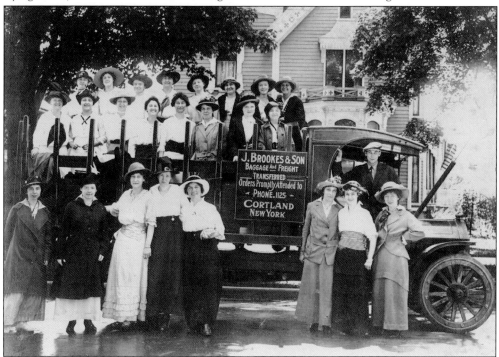

Max Brookes, the "son" of J. Brookes and Son, seems pleased with the cargo his truck will be hauling this particular Sunday. The women could represent a church or a business, and they were prepared to ride in one of Cortland's Liberty Bond parades. The federal government needed to sell a minimum of several billion dollars' worth of bonds to the public each designated date to finance World War I.

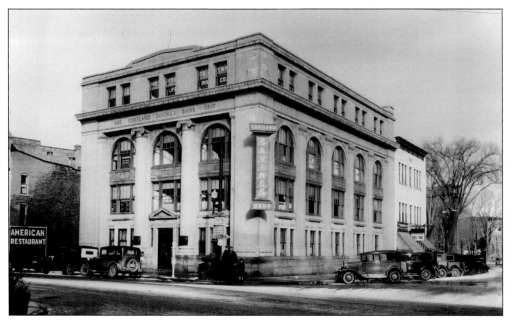

It was a huge move for the Cortland Savings Bank to leave a simple storefront for a four-story building at Main Street and Clinton Avenue. Its size and style represented its strength as a financial institution in 1917. An elevator tended by an operator could take visitors to their choice of floors. Note the directional sign for Route 11 and Harrington Brothers Music store in the Lucid building.

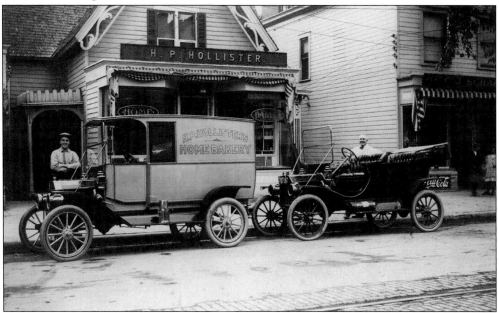

Hollister's bakery was from the same family as the Cortland Baking Company, but Hollister's was a separate enterprise, first located at 7 and then at 15 North Main Street, north of the Savings Bank. Harlan Hollister was the baker and confectioner of raised sugar donuts like none tasted since! He also had shops at 98 Main Street and in the Squires block at 1 Tompkins Street, where he lived.

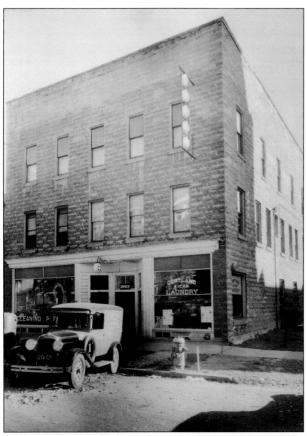

The Cortland Steam Laundry at the corner of Clinton Avenue and Washington Street (now a large apartment house) cleaned carpets and renovated feathers, among its usual functions. The laundry at 15 Court Street around 1910 featured a collar moulder that could shape 10 (stiff) collars a minute and a 164-foot-deep well that provided nearly soft water. Home and business delivery was available.

Smith Corona Typewriters came to Cortland in 1919, constructing a two-story brick building on Huntington Street to hold two keyboard assembly lines. In 1959, it moved to Route 13 in Cortlandville, where 3,000 portables were produced daily in 40 different models in more than 600 variations. As many as 5,000 people were employed. The North American Free Trade Agreement's (NAFTA) gain became Cortland's loss when the plant moved to Mexico in 1992.

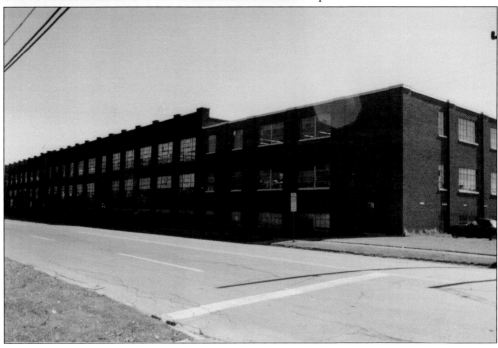

Three

THE 1920S AND 1930S

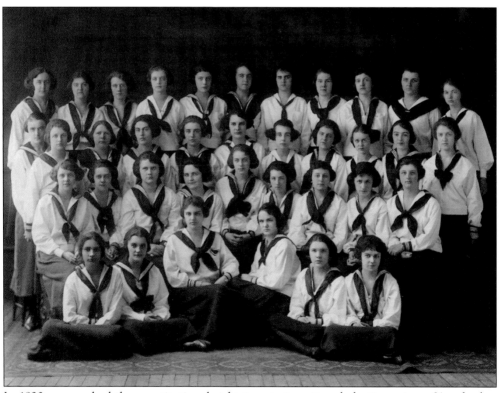

In 1920, women had the constitutional right to vote in national elections at age 21, a further equality step for young women such as these Cortland Central School Delta Epsilons. But rather than exhibit a sense of independence, they chose to dress as one in middy blouses. Perhaps, though, this was an "all for one, one for all" statement for the sorority.

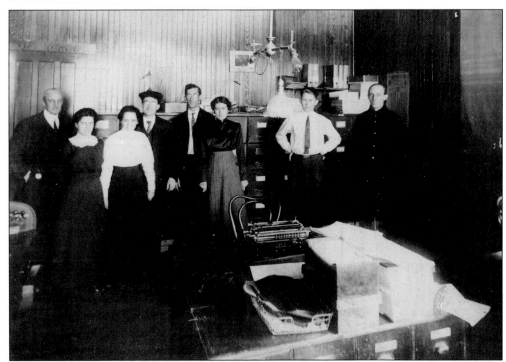

The multi-storied wooden building of the Cortland Grinding Wheel Company, extending from Elm to East Garfield Street along North Franklin Street, began in 1902 to produce grinding wheels from corundum for a worldwide market. Some 60 people were out of work when fire destroyed the complex. Some of the male staff was transferred to a company plant in Chester, Massachusetts.

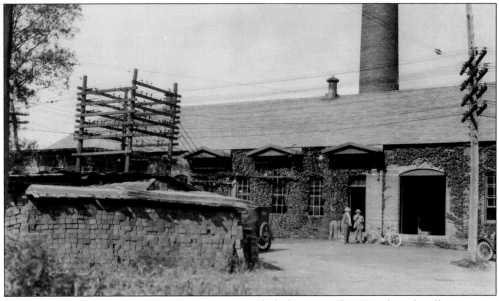

The Cortland County Traction Company provided electricity for 17 miles of trolley service, streetlights for Cortland and Homer, incandescent lights for McGraw, and for practically all businesses in the city. Its offices were on Clinton Avenue, while its area of operations was on today's Traction Drive, where the county's public works department is lodged today.

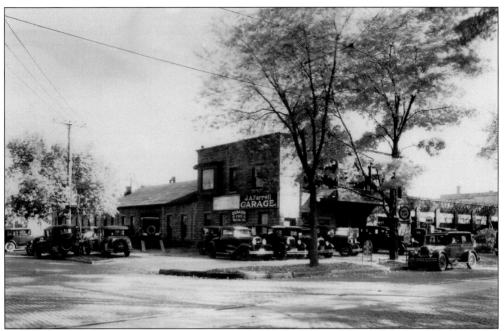

Cortland has always practiced recycling, as shown here at the former armory, which had been used as a feed business, a roller-skating rink, an auto club, and as Farrell's Garage at the southeast corner of Main and William Streets. Buicks were the preferred vehicles there, with young men eagerly waiting to be asked to go to Detroit and drive one back to the city for waiting customers.

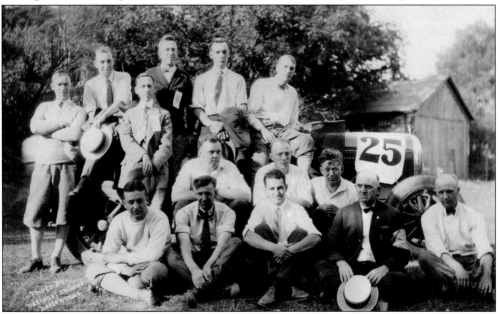

Labor Day 1924 was the second annual hill climb for the automobile club. Five events were scheduled on a Virgil hill course of a mile and a half with an average grade of 6.8 percent. Fifty entries were expected from local and surrounding communities, which produced 10,000 spectators. John McDermott (first row, second from right), known statewide for conservation projects, was chairman of the meet.

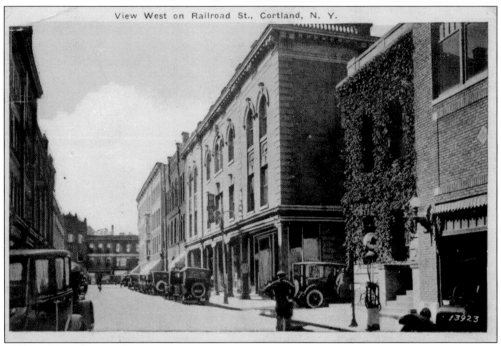

View West on Railroad St., Cortland, N. Y.

Central Avenue was Railroad Street until about 1925. The vine-covered business is the telephone company, and north is the Goddard block with the arcade, which replaced the Wickwire Brothers hardware shop. The darker structure housed the Cortland Business Institute, the *Cortland Democrat*, and eventually, Harrington Brothers music store. The street ends at Burgess's Clothing.

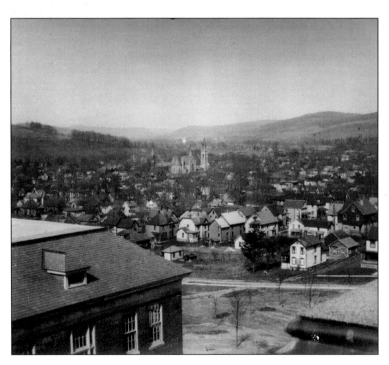

From the roof of the new Cortland Normal School on Court Street hill, looking northeast, is a city filled with trees, the Homer Avenue Methodist Church directly left, and St. Mary's Church in the center. Hills rise around the scene. Homes of this 1923 neighborhood are recognizable today, still housing families rather than the nearby college students.

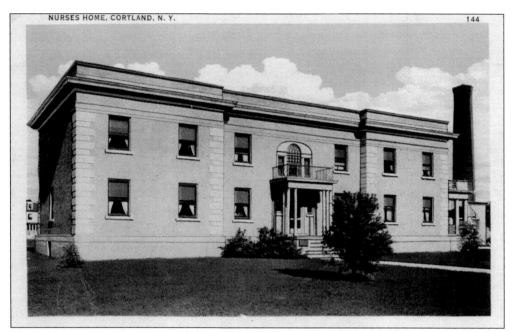

The need for housing the nurses and those in training at Cortland Hospital inspired the construction on West Main Street of a handsome building in a style to compliment that of the hospital. Funds were donated as a memorial to the veterans of World War I. It was safe, convenient, and inexpensive for the women. Within two years, George Brockway met the need for a new wing. Hospital additions replaced the nurses' home.

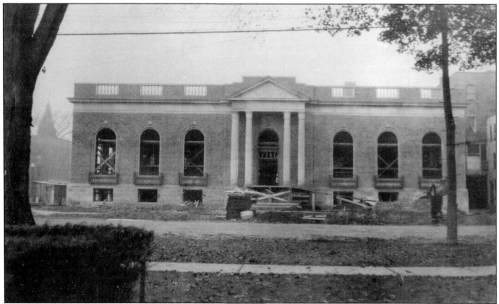

Charles C. Wickwire saw the need for a new library and purchased the property of the second courthouse for $7,000, giving it to the sponsors of that venture. Carl Clark was commissioned as the architect, and donations of $110,000 were received, with Cortland native Elmer Sperry gifting $10,000. In later years, the will of a former librarian enabled space to be increased on mezzanines inside this 1929 facility.

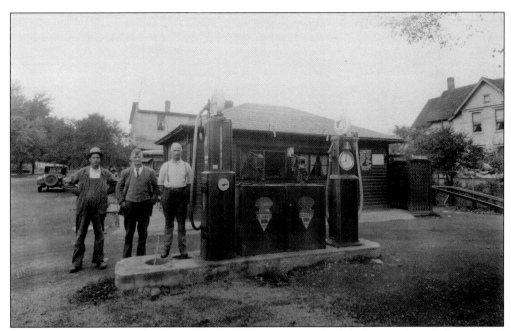

Will Cooper, far left, lived at 2 Van Hoesen Street. Cooper had dealt in junk at 3 Van Hoesen Street and lost a major junk yard on Elm Street to fire. Since the creek's flooding was not such an obstacle any longer, he opened a gas station at 3 Van Hoesen, where the Arctic Ice Cream Store and the Kleen Korner would eventually stand. The building behind the pumps offered lunches and restrooms.

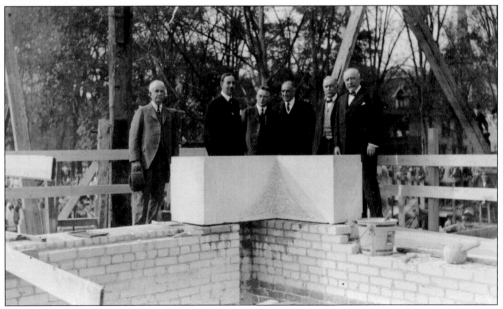

The fire losses of the normal school and the 1838 courthouse occurred one after the other and left prime land vacant in the city's center. A new courthouse was the decided choice to fill the part. At the cornerstone laying, the most auspicious guest was the Honorable Alton B. Parker (far right), a county native who had been the Democrats' presidential candidate against incumbent Theodore Roosevelt in 1904.

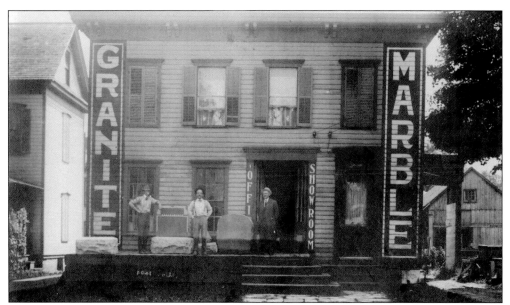

S. M. Benjamin opened the Monument Works at 37 North Main Street in 1854. In addition to cemetery and other memorials, he could provide marble for surfaces in homes. He also claimed to have owned a bakery and built the village's first baker's oven. In 1924, the business was sold to John Betts, who moved into the building to the left, where it continues under new ownership.

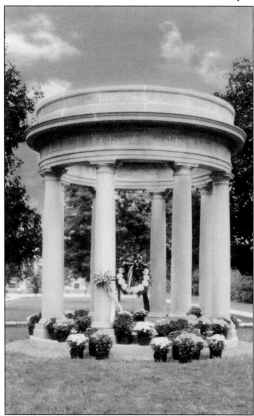

World War I veterans were memorialized in 1926 by a classical design made of Indiana Celtic limestone placed in the courthouse park. An inscription reads, "Lest we forget Cortland's sons and daughters." There is a display in the courthouse of bronze plaques bearing the likenesses of 41 of the 43 men from the county killed in the war. (Photograph by James Sponaugle.)

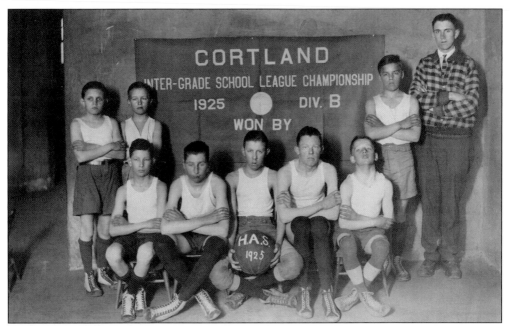

Looking none too pleased with winning the championship are these boys from the Homer Avenue School, located across from the hospital. Their coach is Roland Randall, better known as Rol, who for many years was the sports writer for the *Cortland Standard*. Pictured are, from left to right, (first row) Bainbridge, Randall, Garner, Knolls, Burns; (second row) Stanton, O'Shea, and Sharp.

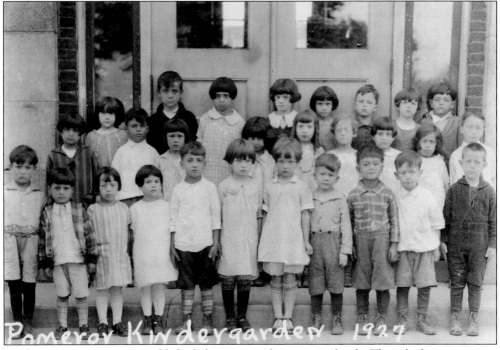

Kindergarten was now an established class in city elementary schools. These little ones are not smiling, which may be a clue that it took some time for the teacher and the photographer to get each and every one in line. Note that the arms of the front row are tight to their sides.

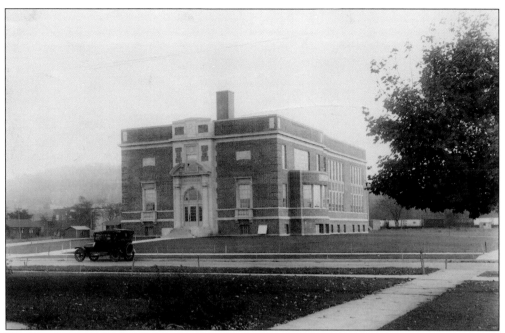

The Randall School of 1927 was named for the families of brothers William and Roswell Randall, the village's first entrepreneurs. It was constructed to accommodate an emerging new neighborhood, as exemplified by the bungalows just built on Huntington Street behind it. Carl Clark designed both the school and those homes. The 12-room school cost $150,000.

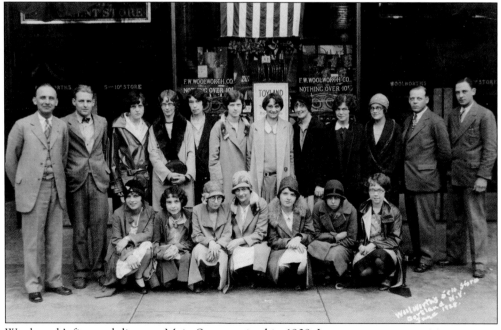

Woolworth's five-and-dime on Main Street arrived in 1909. It gave new opportunities to young women for employment outside the home. From this time into the 1990s, Woolworth's, Kresge, Newberry, Fishman, and Grants competed on Main Street for the city's nickels and dimes. In 1961, Woolworth planned to move to the Groton Avenue Shopping Plaza, but it closed instead.

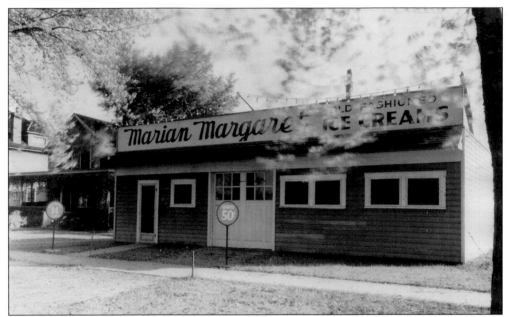

Marian Margaret Brown was the source of the name for the 1928 family business at 3 Huntington Street, which was enlarged by a new building, using the old one as a wing in 1936. During World War II, a very small lunchroom was launched on North Main Street near the theater. That was replaced when the Browns opened a Clinton Avenue restaurant in 1944. Everett Salter purchased the firm in 1954.

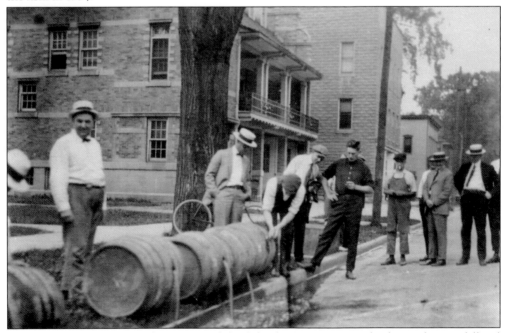

Prohibition was in effect in the 1920s, and the federal government sought the producers of illegal beverages. The newspapers announced the arrival of agents in the city, and the location of stills and speakeasies was usually an open secret in their neighborhoods. Confiscated barrels are drained into the gutter outside of city hall as city judge Louis Dowd, in gray suit, stands at the right.

Adelpha Cortright wore a gown of white taffeta and carried white roses and sweet peas in her marriage to Alex R. Seymour in August 1929 at the First Universalist Church, where her late father had one time been the pastor. Following the ceremony, the wedding party adjourned to the Cortland Country Club for a wedding breakfast and photographs.

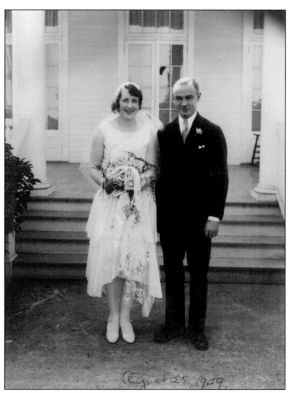

August 25, 1929

Plans to fly to New York City were to be secret, but the wedding party was joined at the flying field (a farmer's grassy acreage) by a crowd of spectators, as this was the first aerial honeymoon to have taken off from Cortland. The bride was now in a going away outfit, which might have been more appropriate for flying in the open American Eagle, piloted by Lt. C. C. Cameron, at left.

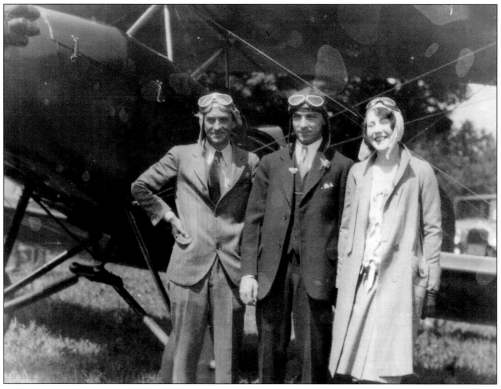

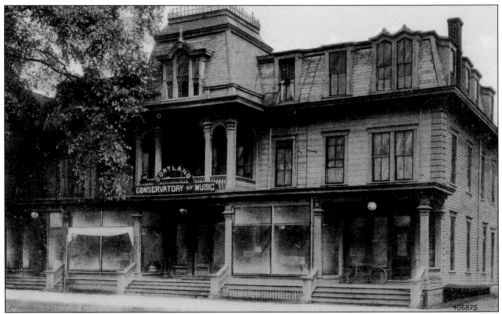

The Cortland Conservatory of Music on Court Street thrived with its four-year course certified by the state regents. Violins to vocals, drums to harps, elocution, drama, and art were taught at affordable rates to literally thousands of students in the 1840 relic of a hotel. Students like Spiegle Willcox would provide entertainment for decades. In 1945, it was replaced by a building to sell Buicks that now sells stocks and bonds.

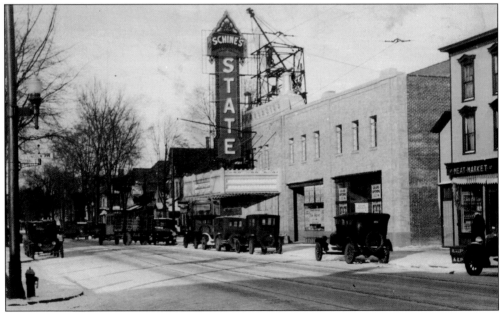

Shine's State Theater even had a small parking lot. The decor might be described as Persian, and the large stage invited vaudeville acts, since the former Opera House was no more. Zaharis' ice cream parlor rented next door. From December 1930 until the 1950s, there was little competition, but television changed that. The "final curtain" was the purchase of the building by Cortland Savings Bank in 1973.

Robert Beard and N. J. Peck came together in 1888 at 9 Main Street. They combined undertaking and furniture sales and occupied the four floors. Beard left to pursue undertaking south of the corner of Church Street and Central Avenue, then to a grand house at 18 Church Street. Beard later joined Wright's Funeral Home. Peck remained at Main Street, moving later to 23–29 Central Avenue, expanding to Cortlandville, and closing in 2006.

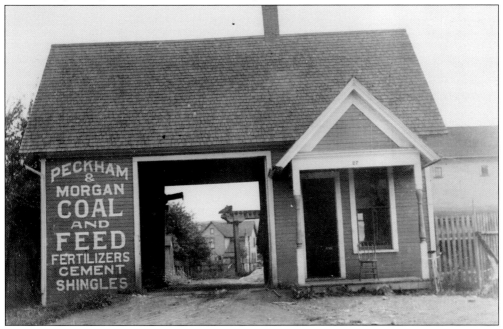

A small area in an older home's cellar may generate questions and likely it is the remains of a coal bin. Coal was an important commodity up until the 1950s. Peckham and Morgan, at 27 Squires Street, had a private siding for the Lehigh Valley's coal cars and a trestle that could hold six coal cars. Homes ordered coal by size and tonnage, and it was delivered into the cellar through a bin's window.

The first manufacturer owned by J. C. Penney's was the Crescent Corset, beginning upstairs at 29–31 Railroad Street with 38 machines in 1920. In 1923, the Crescent moved to south Main Street. In 1949, it was sold to members of its local management. It was resold several more times, the last time to Maidenform, and they declared bankruptcy. The 17-foot-by-3-foot letters of the roof sign were a guide to the local airport.

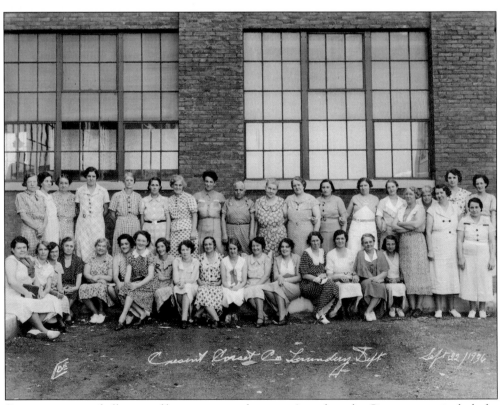

Sewing corsets and all types of lingerie was truly women's work at the Crescent, particularly for young women arriving here from Italy. Many had sewing skills. Some of the supervisors had gone through the same immigrant experience and could help these new workers. Age was not a factor in determining how long one was employed. Good work was repaid with secure longevity.

Columbus Field (Rambler Field) was located off Carroll Street, on the edge of the fair grounds. Seating was on rough bleachers or in an even rougher grandstand. Baseball fielded industry teams, community, and semi-professional nines into the early 1950s. The Groton Coronas and the Homer Braves, with John Gee pitching and Jack Tuthill switch-hitting, could always draw a crowd. Fall football games would follow summer's sports there.

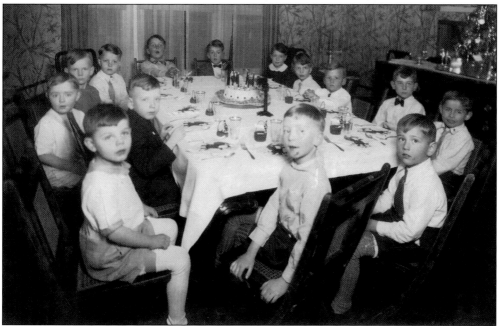

Sonny Barker celebrated his Christmastime birthday at his home at 54 Church Street with friends Jay Peck, Charles Gardner, Charles Haskell, and John Dwyer, but, unfortunately, it is not known which boy is which, even Sonny. The boys have Santa napkins, baskets of small candies, a large cake with large candles, and a decorated tree. Note the long stockings (with garters) for warmth.

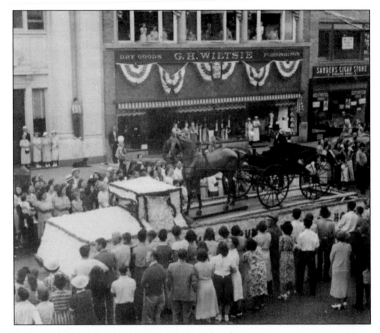

Cortland loves parades, but it is the decorated G. W. Wiltsie building which holds the attention. It was a major loss to downtown (or uptown) when it closed in 1975. It had been the county's largest store for women's clothing and accessories, children's wear, china, cosmetics, patterns, and yards of material. The 1925 building had three floors, a mezzanine-level office, and an elegant entrance like no other.

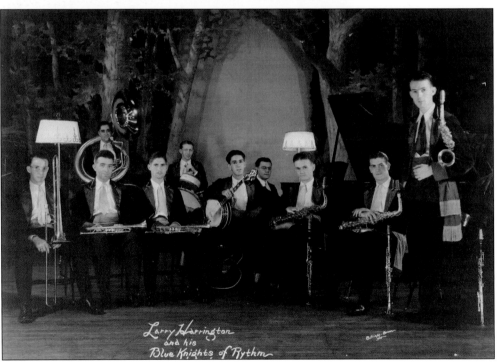

In 1930, Larry and Reginald Harrington bought out the Ghent music store on Clinton Avenue, just east of the savings bank. Larry's saxophone and dance orchestra were already well known in Central New York. In 1947, the brothers bought the *Cortland Democrat* on Central Avenue and moved the music business next door. The newspaper no longer prints, but Reg's son continues as proprietor of all things musical.

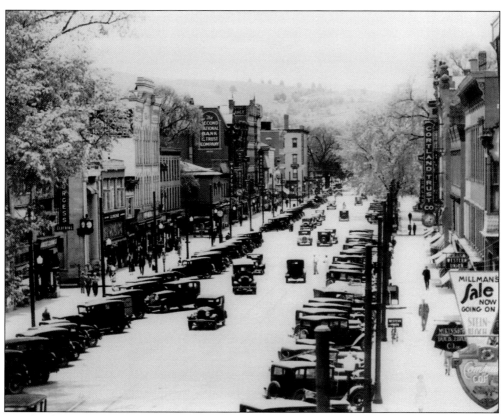

Cortland's wide Main Street easily accommodated two-way traffic and angled nose-to-the-curb parking in the 1930s. Vertically lit signs were prominent, and there was an abundance of streetlights. The First National Bank (a 1937 combination of the National and Second National Banks) was constructed at the corner of Main Street and Central Avenue; its clock is now an icon of its past.

Continuing on Main Street, there is the Chocolate Shop, Alperts jewelry, Woods shoes, and the previous Markson's Furniture Store location. The shadow is actually a separate building between two other look-alikes. It was destroyed by fire and replaced by a one-story building. The facade of the one on the right was completely changed to disassociate itself from the age of the remaining one.

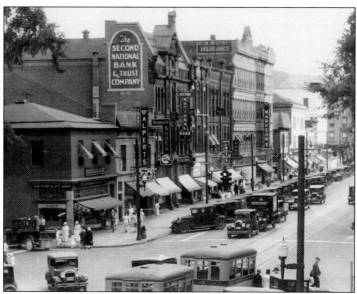

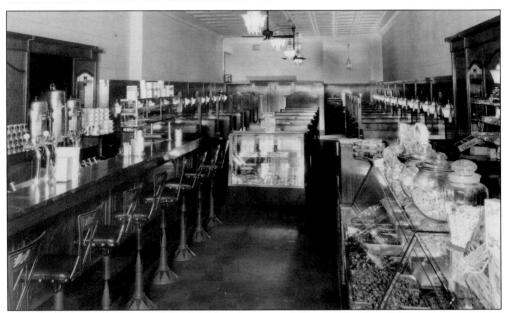

The Community Coffee Shop's life began in July 1930 when it followed the El Dorado restaurant. All seating for its 100 customers was in booths in the center and both sides. Polished mahogany was everywhere. It sold a variety of candies. A new owner in 1933 dubbed it the Community Grill. Family run for many years, its popularity continues as the Community Restaurant in an expanded space.

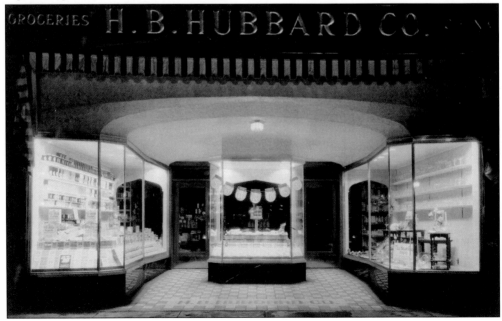

Henry B. Hubbard entered the grocery business in 1881, and for most of his business years, food, Haviland china, and grass seed were sold from the same location at 96 Main Street. With the advent of telephones, orders could be called in, delivered, and charged. These were major conveniences for his customers but proved to be the store's downfall. It closed in 1932 because of customers' unpaid bills.

Shaw and Boehler Florists opened in 1923 with greenhouses flourishing for many seasons. It provided the city's first floral shop at 11 North Main Street for 33 years and grew its selections on Miller Street. When Earl Shaw retired in 1957, an auction was held, and the business was divided. In 1997, the owner of the shop moved it to 31 Clinton Avenue in order to enjoy more space.

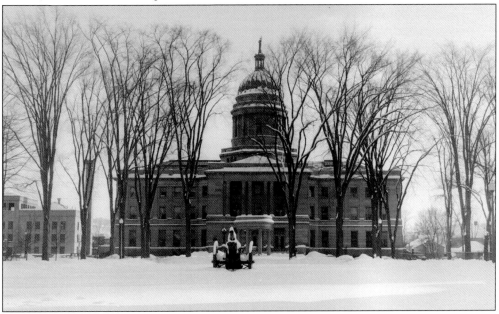

The elms no longer shade Court House Park, and the World War I cannon does not tempt children to climb upon it. Disease took the elms, and perhaps a World War II scrap drive made use of the gun. During some winters, there has been ice-skating here, but activities abound in the park the rest of the year. The county jail is to the left and is larger now. The cupola is lighted at night and is a thrilling sight to view.

Champion Sheet Metal Company was founded in 1892 to make milk coolers and dairy equipment and then began making sheet metal parts for trucks. By the 1950s, it was making hoods, fenders, cowls—especially for Brockway Motor Trucks, but also for fire engines and mobile cranes—and machine parts for an incredible variety of industries at 1 Squires Street and at the Junction.

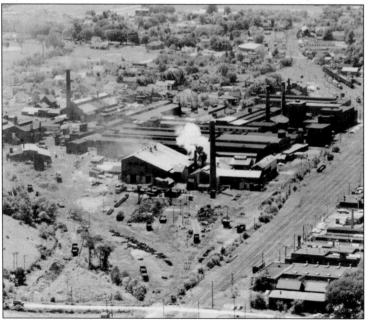

Wickwire Brothers, Inc., was the result of the industrious and ingenious brothers Chester F. and Theodore H. Wickwire, who began in the city with a bicycle repair shop and ended with a steel mill. They moved to one building at Main Street and the Lehigh Valley Railroad tracks in 1881. Each success was followed by additional structures. Businesses in the lower right corner are facing Huntington Street.

In 1939, sculptor Alex M. Law was hired to create an appropriate design for the Greenbush Street entrance to the new addition of the high school. The gym, which continues to serve the public to this day, had accommodations for the male athletes' sports. Girls' sports inherited the old gym. The part of the original school that remained, following other additions, was then torn down.

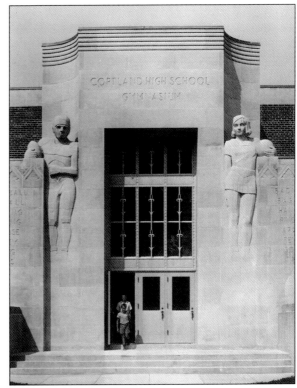

Until World War II, graduating from St. Mary's High School provided pomp and circumstance in the church on a Sunday afternoon, with the pastor dispensing blessings and diplomas, all under the eye of Sister Merici. The 1939 girl pages wore pink dresses made by mothers or seamstresses using the same pattern. Boy and girl pages processed in, carrying the diplomas. Note the smiling graduates.

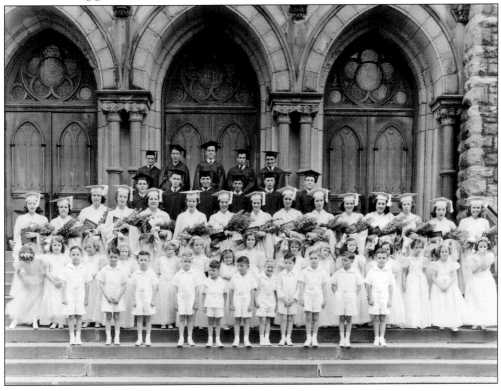

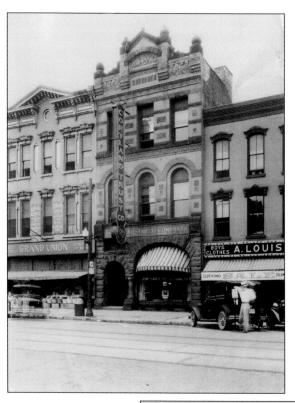

The stalwarts of the west side of Main Street were these businesses. In 1937, the bank, in an 1887 building, replaced its facade with buff-colored Indiana limestone with a marble inlay, redid the interior, and became the Marine Midland Bank (now HSBC). Grand Union was a local competitor from 1910 in several Main Street locations. A. Louis moved to 3 Main Street until a fire forced another address change in 1978.

Theodore Stevenson's home was a three-story Queen Anne at 7 Church Street, now completely unrecognizable under layers of concrete. In 1889, he built this brick building at the southwest corner of Pomeroy and Elm Streets. Among its uses was as a meeting hall for the Sons of Italy. His record of accomplishments was three factories, 100 new buildings, and a street that bears his name.

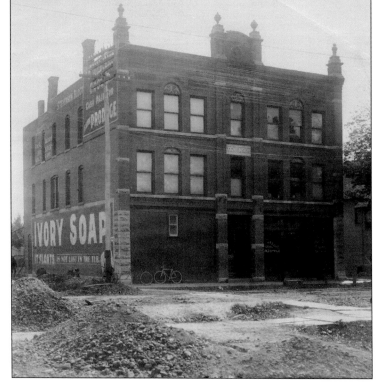

Four

DECADES OF CHANGE

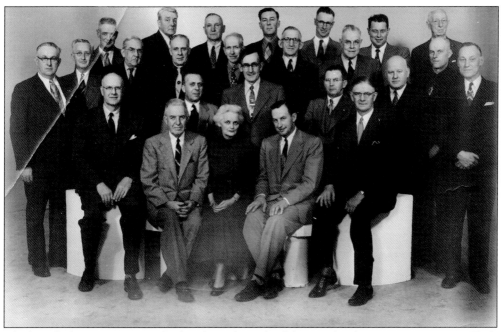

The board of supervisors was the legislative branch of the Cortland County government. Each town elected a town supervisor who served this dual role, and each city ward elected a board member. From the fourth ward, Susan West, the board's first woman member, served from 1941 until 1956. Many women have since served with distinction on the county legislature.

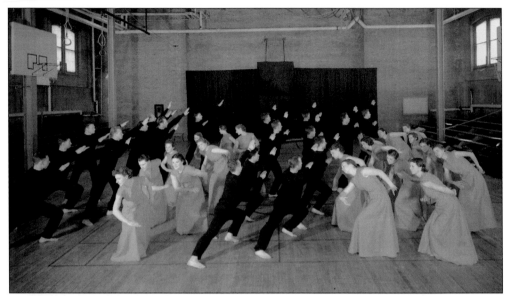

Mary Washington Ball was a pioneer dance instructor on the normal school physical education faculty from 1923 to 1950. In addition to what usually was called "modern dance," she brought every such dancer of significance to the campus to inspire her classes, whom she encouraged to develop programs for public viewing. Male students around 1940 were athletes looking for a career in coaching, and Ball's classes were true bodybuilders.

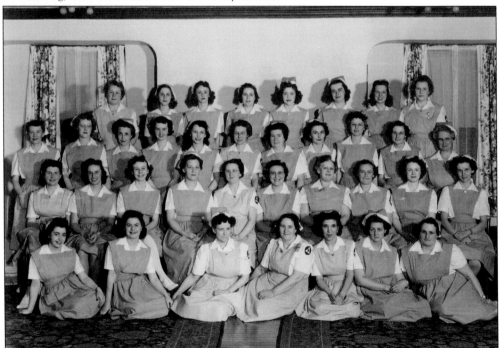

The Cortland Hospital met the wartime shortage of help by recruiting women volunteers. From 1942, the Red Cross Nurses Aides worked directly with the patients' care through bed linen and bedpan changing, much of what the former practical nurses did. Gray Ladies served in a more social way, delivering mail, flowers, and the library cart. Both contributions were very important.

Cortland's young men began enlisting in the armed services in 1941, before the United States was at war. To recognize those drafted and the enlistees, their names were spelled out on this two-story board. A gold star identified those who would never come home again. This testament to the bravery of all stood on a grassy lawn between the Savings Bank and the Churchill block on North Main Street.

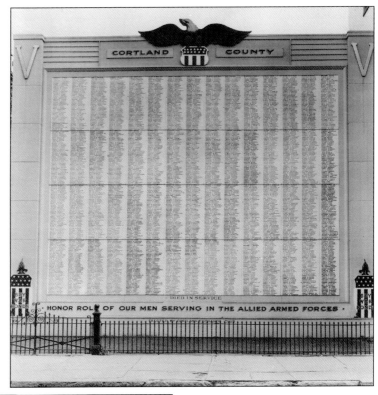

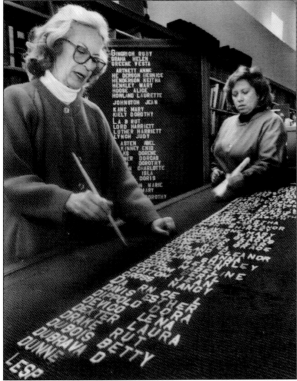

The Cortland's Community Players, a theatrical group, campaigned in 1944 for a display in Court House Park that would name the women who served during the war. Later, it was dismantled and its parts given away. Kathy O'Gorman of the League of Women Voters located pieces in 1993 in a Homer attic. O'Gorman, on the right, and the historical society's director are shown cleaning what remains of the name boards.

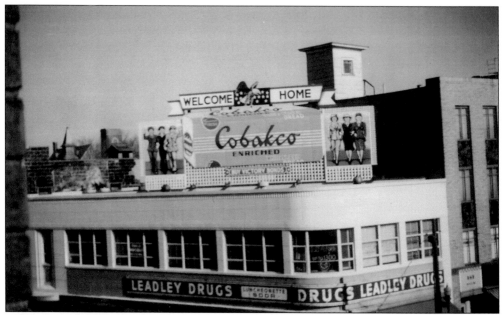

Cobakco, the Cortland Baking Company, saluted the returning veterans from its regular advertising perch on top of Dr. John Wattenburg's building at the southeast corner of Main Street and Clinton Avenue. For emphasis during the day, loud speakers broadcast the songs of the branches of service. Letters of appreciation were received from veterans by the bakery and the *Cortland Standard* for this public display.

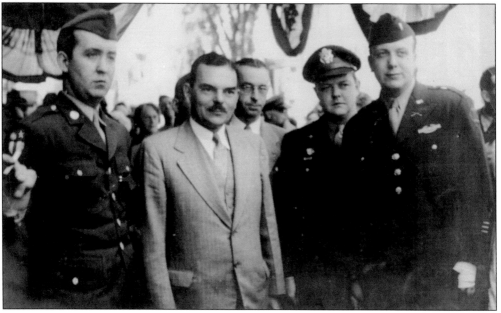

The first anniversary of V-J Day was approaching. To commemorate the August date when victory over the Japanese was achieved, ending World War II, New York state governor Thomas E. Dewey was invited to review a parade that continued for 3 miles. From left to right are Malcolm Alama, Governor Dewey, Assemblyman Louis Folmer, U.S. Air Force major Levi Chase, and U.S. Army lieutenant Ernie Greup.

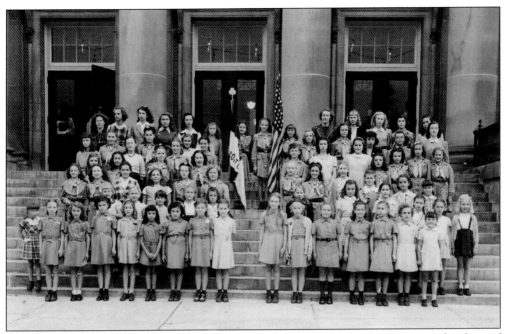

Girl Scouting flourished in the 1940s, with meetings in churches and schools. Pictured in front of the college, these girls represented Brownie, Intermediate, and Senior Scout troops. Jean Haskell Sweeney—top row, right of the flag, wearing a blazer—was a local student who volunteered as an assistant to a troop leader.

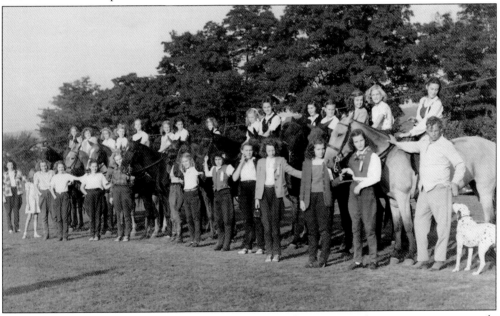

Summer for Girl Scouts in the late 1940s was not just for camping. Arrangements were made with the polo club just north of Homer, New York, for scouts to have horseback riding lessons. Some horses were club members' polo ponies, and others were part of the club's contract with the manager, at right. Riding on an English saddle and wearing jodhpurs was a new way to earn a merit badge.

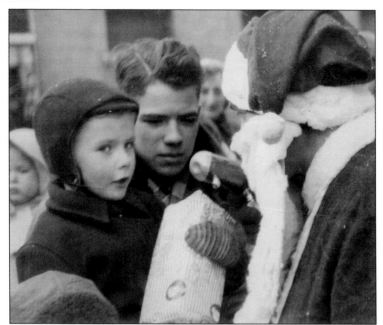

Harry Glover Jr. held his much younger brother Douglas on Main Street at Christmas 1948 while Santa Claus (Ernie Greup) of radio station WKRT interviewed Dougie about what he wanted Santa to bring (besides the loaf of bread). After graduating from high school, Douglas enlisted in the U.S. Army. He was lost during the Vietnam conflict.

After 11 years in Syracuse, Gooley-Edlund moved to the city and then to Huntington Street in 1918, as labor relations were considered better in Cortland. The company produced heavy milling machines used in the production of automobiles, household appliances, electrical equipment, missiles, ships, airplanes, and farm machines. The economy in 1933 forced a closing, an auction, and an Edlund survival.

There was never really enough room in Peck's Furniture Store at 23–29 Central Avenue, so every sliver of space was a part of its showrooms. As businesses on Routes 281 and 13 increased in number, Peck's built a handsome new showroom adjacent to Lamont Circle, eventually closing its downtown store. A victim of changes in lifestyles, the suburban store closed in 2006.

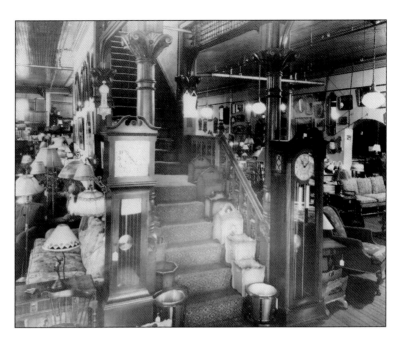

E D S O N ' S
44 Port Watson St., Cortland, N. Y. Telephone 1522
HOME COOKED MEALS : : : : : : GUEST ROOMS
Reservations not required.
On Route 11, Between Binghamton and Syracuse

Clara Edson's mother ran a boardinghouse in what had been a majestic house at 10 Prospect Terrace. Boarding of course indicates that meals were served. Her mother then moved to a house on West Court Street operating as a restaurant. Clara continued the course her mother set at the above location, and moved in 1945 to 91 North Main Street when this property became the first Temple Brith Sholom.

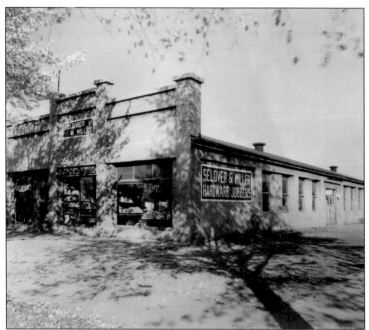

Main Street's west side, south from Tompkins Street, owned by the Randalls, was sold gradually to prosperous businessmen for homes. However, 100 acres opposite the houses, extending east to Pendleton Street, was also Randall property, unavailable for purchase until about 1910. Deeds had stringent restrictions, so businesses such as Selover and Miller occupied Main Street's lower east side rather than residences.

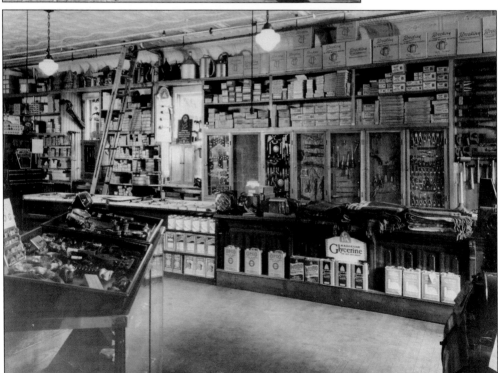

Taking inventory at Cortland Auto Supply could never have been easy! Opening in 1913 on Railroad Street as Letts and Stanford, it came to operate under three generations of the Starr family. It moved to Court Street (the former European Hotel), its most familiar locale, in 1917. Tires, vehicle accessories, and wholesale and retail replacement parts were its primary sales in its long history.

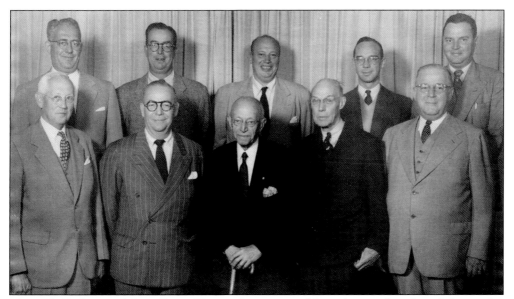

The 1950 Fathers and Sons Day of Rotary International brought together, from left to right, (first row) Ralph Bennett (Champion Sheet Metal), Fred Beaudry (Beaudry Wall Paper), Dr. Paul Carpenter, Charles Wickwire Sr. (Wickwire Brothers), and John Briggs (Briggs Cadillac in Homer, New York); (second row) John Bennett, Charles Beaudry, Dr. Robert Carpenter, Charles Wickwire Jr., and Walter Briggs.

In the 1950s, Cortland and the U.S. State Department were implementing plans for a sister city relationship with Peshawar in the emerging country of Pakistan. Since then, many changes in government and attitude may make this concept of a way to further world peace seem naive. The gentleman in the suit was a minister from Pakistan visiting Cortland.

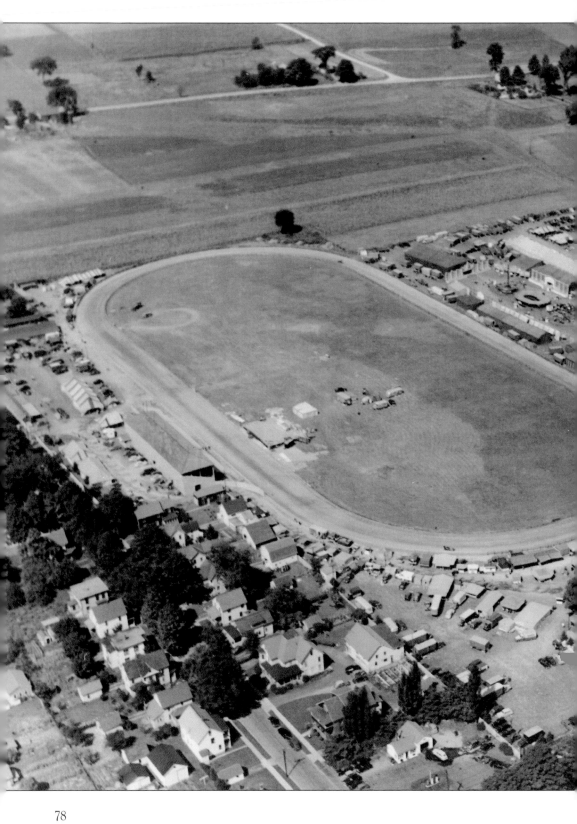

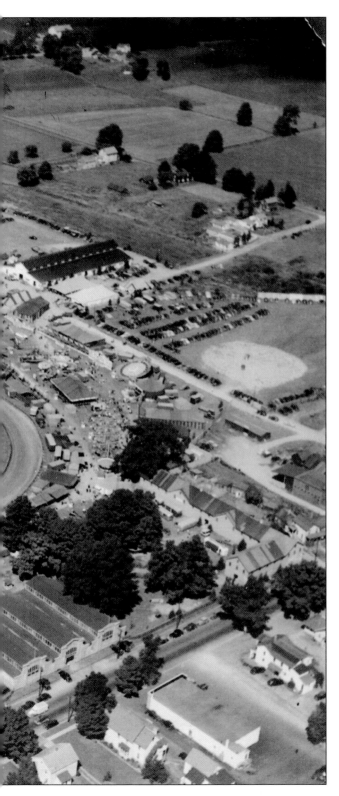

It is difficult to describe to anyone under 60 what the Cortland County Fair was like before it lost out to supermarkets and gas stations on North Homer Avenue. Sheldon Booth's 1952 photograph says it all. From the race track to Route 281 (the back road) were open fields. The stage in front of the grandstand seems very small, but it was large enough for Louis Prima and Keely Smith in 1951. Harness racers, daredevil auto drivers, and rodeo competitors performed. Along the rail leading to the grandstand were the food tents, where absolutely nothing smelled or tasted better than Ang Natoli's hot pepper sausage sandwiches. Bingo with dirty kernels of corn as markers, scary rides, farm animals, crafts, homemade pies, and the "girlie" shows made for a wonderful finale to summer. (Courtesy of Virgil L. Moffitt.)

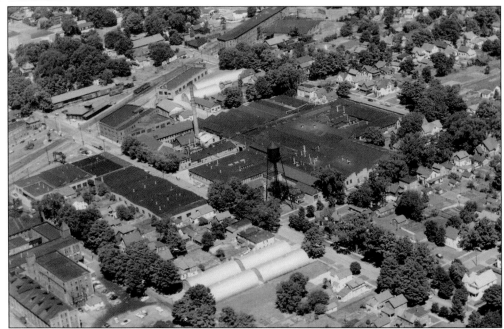

Brockway Motor Truck Company sprawled across its east side neighborhood. Since the 1930s, its trucks have been known as "legends of the highways" for the backbreaking work they performed in this country and abroad. They were standouts in World War I and II. They continued their reputation in Vietnam. From 1956, the company was owned by its biggest competitor, Mack Trucks.

The focus here in 1961 was on buildings along the first block of Port Watson Street that are now long gone. The Loyal Order of Moose purchased the 1821 Johnson house in 1922 and moved it to the back of the lot, where a brick addition with open porches was built. The Moose moved in 1956, and the Assembly of God Church and Max Rosen's used cars were not far behind.

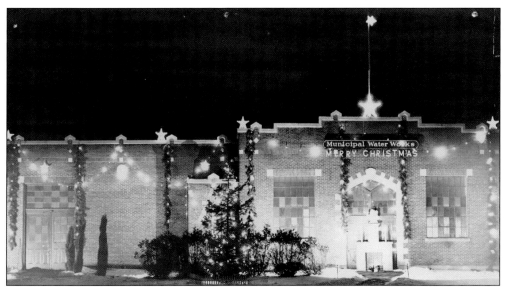

For more than 50 years, the city has looked forward to the Christmas decorations at the Water Works. A private company created the Water Works in 1884 with exclusive rights to sell water in the village. The artesian wells are the only source to supply the city and Cortlandville. The attractive pump house is the background to the park, with its deer, pond, ducks, geese, and fish.

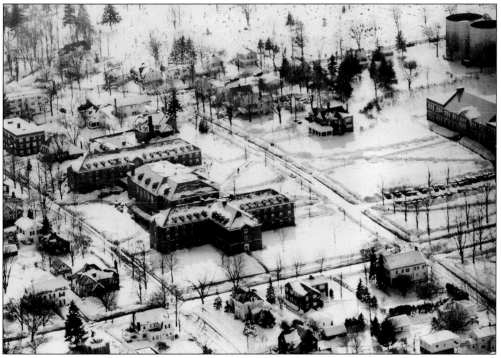

The 1950s began the expansion of the college on the hill, no longer a normal school. The large building consisted of two dormitories with Brockway Hall in the center as a student union. Set back from Graham Avenue and facing east was the physical education building, Moffitt Hall. Just south of that was the president's residence of that time period. Cortland Rural Cemetery rests beneath the snow to the south.

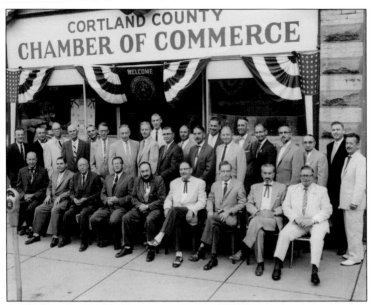

Cortland County's sesquicentennial year, 1958, was packed with activities to involve the public, including a beauty contest at the annual county fair and a parade of floats, where the use of crepe paper took spectators' breath away. Men were encouraged to grow beards by being fined if they did not. They wore string ties that were supposed to be reminders of their roots. Dick Wilkins, front row center, was the general chairman.

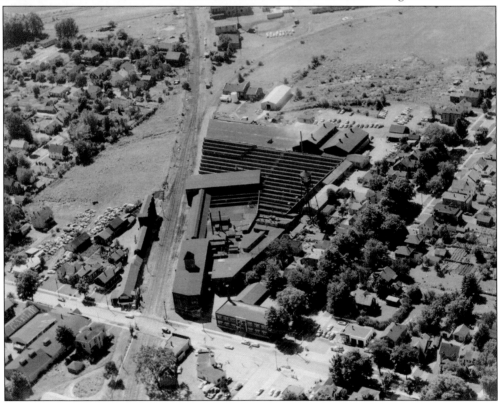

Brewer-Titchener Corporation stretched along the Delaware, Lackawanna, and Western Railroad tracks at Port Watson and Pendleton Streets. Initially it majored in the production of steel and leather bow sockets to coaster brakes. In 1908, the company consolidated with Binghamton's Crandall Stone Company and Cortland's Forging Shop. It used 30 tons of steel annually in making parts for use by other firms.

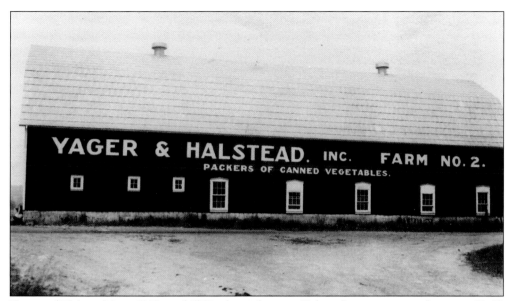

Yager and Halstead from 1901 until 1918, when it became Halstead, was a canning factory at 11–23 Squires Street that produced the Cortland brand. The company owned acreage for beans and corn, supplementing with purchases from farmers. During the summers, 500 to 600 people were employed. In 1945, German prisoners of war were bussed from a Slaterville Civilian Conservation Corps camp each day to harvest and were returned at night.

Loblaw's, a Canadian firm with a U.S. headquarters near Buffalo, came to Cortland's 17 North Main Street in 1942. The supermarket replaced slouching, old wooden buildings with a shiny facade and a large parking lot. Self-service reigned after a 1948 interior redesign. A second store was built at the Cortlandville Mall in a separate facility. The downtown store was closed and removed in 1973.

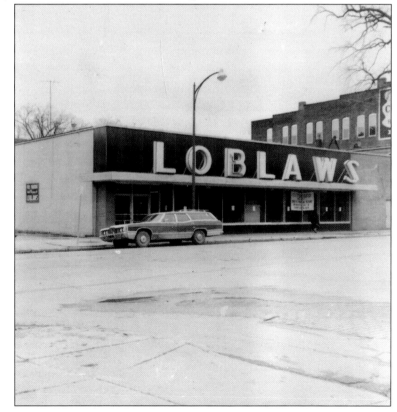

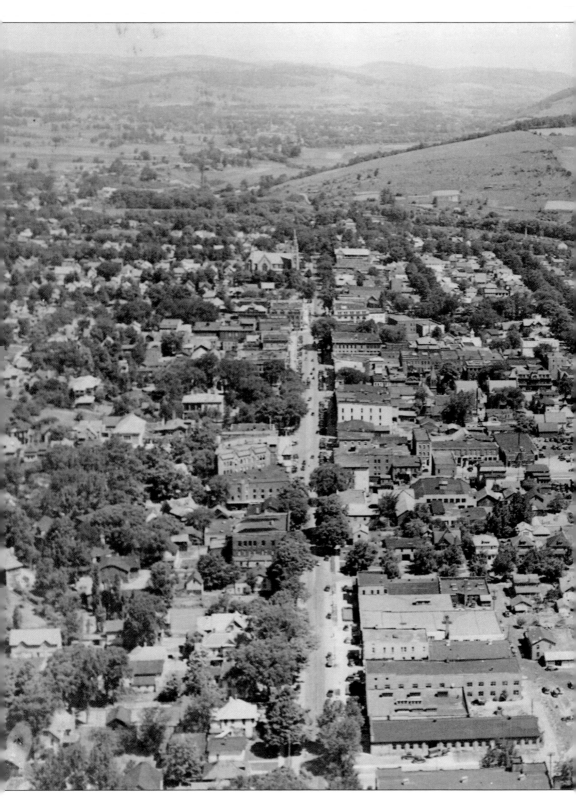

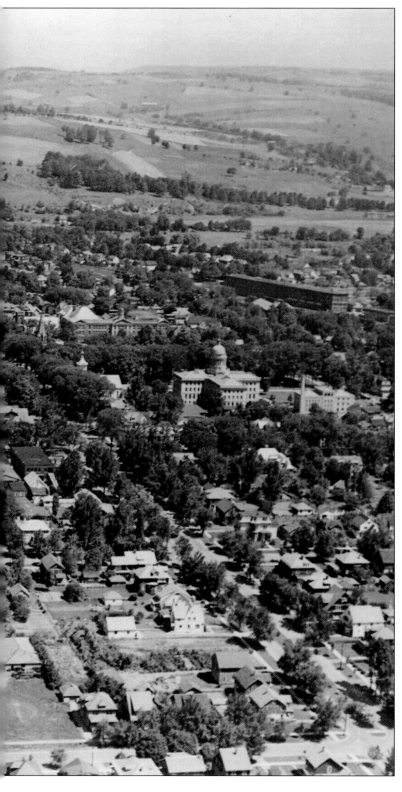

During the 1950s, the location of an arterial highway more than likely would have been disruptive to the norm, although the decision would come from Albany. There was talk of closing Main Street to traffic, creating a shopper's mall, and connecting buildings by overhead pedestrian walks. To survive after World War II, progress was the prescribed way to go! Trees along Tompkins, Port Watson, and Church Streets and Clinton Avenue were victims, and the sidewalk-to-curb space was reduced as streets were widened. Route 11 no longer toured part of Main Street, and Route 13 trundled to Port Watson Street by way of Pomeroy or Church Streets. Route 81 skirted the city, which was good, but avoiding the city was not so good for downtown businesses. Clinton Avenue at the Tioughnioga River became a fast food heaven as other businesses there floundered.

Oh for the days of saddle shoes, Keds, and penny loafers from Sarvey's! Merton Sarvey arrived in Cortland in 1894 and soon owned a shoe store on Railroad Street. His son, John, continued and was later joined by son James. Their memory for shoe size was remarkable. The store moved to 50 Main Street in 1987, taking its 1917 stained glass sign and continuing its history of service.

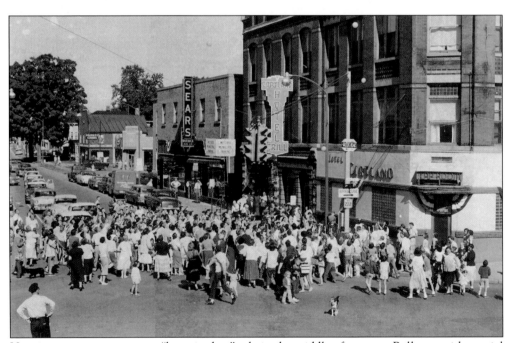

Here is one way to promote a "bargain days" sale in the middle of summer. Balloons with special offers inside were released from an upper floor of the Hotel Cortland. A traffic-stopping crowd responded. The view of Groton Avenue's north side includes the Sears store in the old Opera House (which has lost its upper floor) and Harris Dry Cleaners, original to that building.

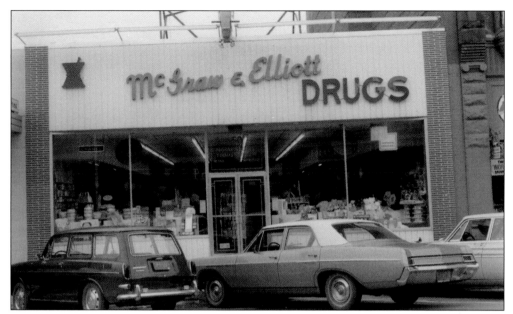

Originally, McGraw and Elliott's Drugstore opened on the east side of Main Street when paint was on the sales agenda and could be delivered to one's home by a bicyclist. At the curb was a bell that customers could ring for service without leaving their means of travel. It also had the first public telephone. Nearby Sager and Jennings was the first village drugstore.

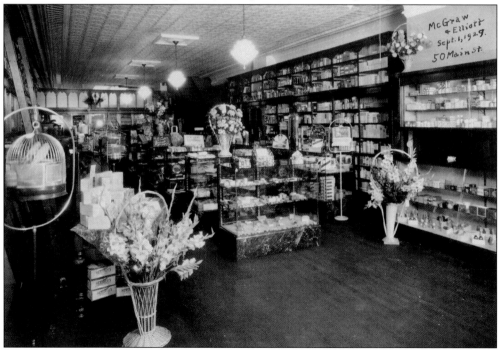

In 1929, McGraw and Elliott purchased the Taylor block and moved into 50 Main Street. The flowers represented congratulations from other local businesses. There are two caged birds in the picture, which could be a welcome gift or a sales ploy. A fire meant the end of the three-story building but not to the drugstore. It moved until a two-store, one-floor building was constructed.

The Harveys owned a swath of land just south of the Tioughnioga River on the right side of Clinton Avenue and on Route 13, which led to Truxton. Part of the buildings shown dated to the 1830s. Their firkin/cider mill was doomed by new bridges. The lumber mill encroached until all was lost to what became a long-vacant gas station and a Holiday Inn.

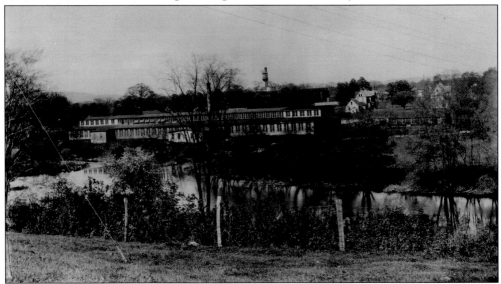

Cooper Brothers Foundry, at 44 River Street, was where the 1823 oil and paper mill had once been. It specialized in large general machinery, averaging 200 to 300 tons of castings a year. The foundry was closed when, by state law, it was required to provide workers with insurance protection against silicosis, a 30-percent additional cost above its other insurance. Its machine shop continued until 1956.

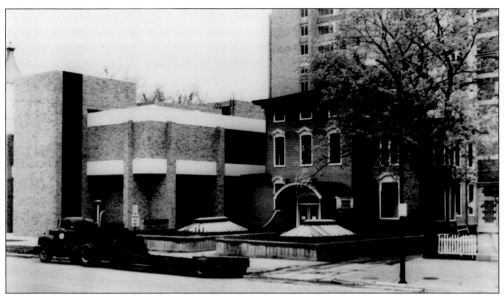

Not many communities could boast two city halls at the same time, although the center building was hardly one of which to be proud. City government and the police station were crowded into the former Wavle home, where public comfort stations were installed in the front yard under opaque glass in 1924. Mayor Morris Noss campaigned for two years for a new city hall, which finally opened in 1968.

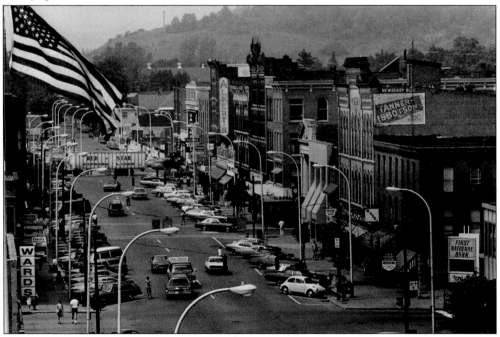

This photograph may be deceiving with its busy accumulation of traffic. One-way traffic on Main Street began as an experiment in 1967. Every so many years, the idea is bantered about in the common council to return to two-way traffic. It was thought the change to one-way traffic would ease Route 11 tractor-trailers off Main Street, but now they park in the middle of the street to make deliveries.

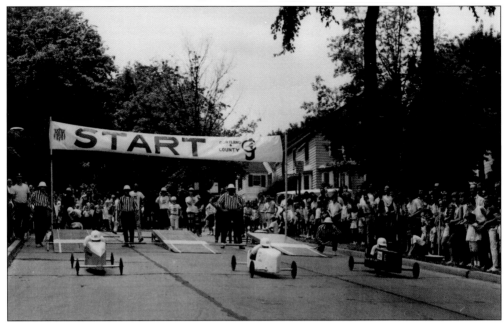

The Junior Chamber of Commerce sponsored the Soap Box Derby contest for many years. The take-off spot this day was West Court Street at Pleasant Street, with traffic halted on Main Street for a safe crossing. Early on, the Owego Street Extension was the racing scene, and in 1976, it was moved to Starr Road. Competition is area-wide, so now Cortland entries compete elsewhere.

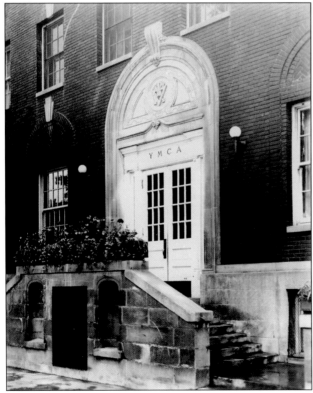

The Young Men's Christian Association (YMCA) was incorporated in Cortland in 1888 and had rooms in the Squires block. In 1899, it moved to the third floor of the Cortland Standard building. By 1915, a brand new, $80,000 building was opened on Court Street. Its handsome front was the background for photographs of departing contingents of World War I soldiers. In 1967, a new YMCA home opened on Tompkins Street.

Hotel Cortland
CORTLAND, N. Y.

COCKTAIL LOUNGE AND BAR

THE COFFEE SHOP

Recommended by
DUNCAN HINES

THE GRILL

The Hotel Cortland provided dining and libations for the community as well as guests for many years, but keeping a building of its age in good condition became more and more expensive, and lack of foresight kept investors from visualizing its potential. So with a heavy heart and a heavier hammer, it was destroyed in 1972 to make way for a muddy, rutty parking lot with potential.

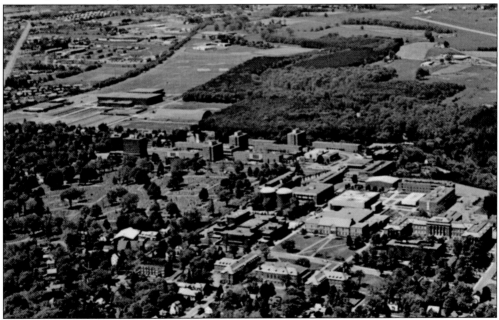

State University of New York at Cortland reached across Graham Avenue and progressed, with construction, west along Prospect Terrace, through the sand banks, and across Broadway, alongside the Water Works' protective cover of evergreens. The expanding campus's dorms went through asbestos removal, a glass tower was added to one dorm, and a stadium complex of impressive dimensions rose beyond the last campus building shown here.

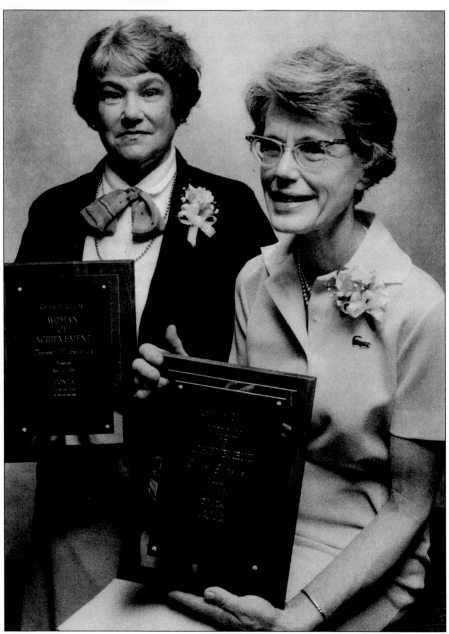

In 1984, the Zonta Club chose to honor Theresa Benedick (left) and Shirley Heppell as signifying Zonta's ideals of service. Both women came to Cortland as a result of their husbands' occupations. Terry, a registered nurse, had earned a bachelor's and a master's degree. Shirley had a master's in library science and a master's in American history. Both worked long and hard to accomplish goals that served the public. Terry's advocacy for senior citizen recreation, education, culture, nutrition, volunteering, and housing opportunities will help ease the aging process for baby boomers and beyond. Shirley, as the county historian and volunteer librarian for the historical society, knew documents and architecture as treasures needing preservation and strove to make the populace aware of their history, which was often ignored or unappreciated. Both are deceased and decidedly missed for their dedication and friendship.

Five

NOTABLE HOMES

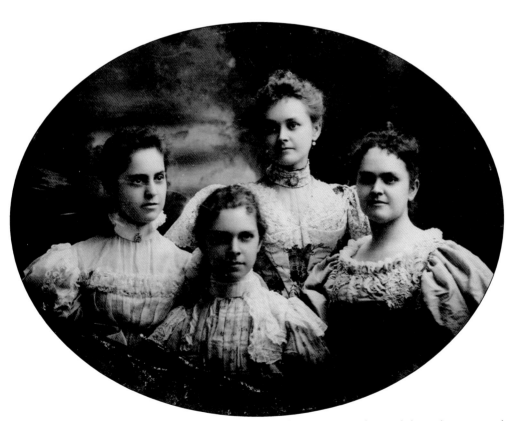

The Fitzgerald girls all lived in one special home. After marriage, three of the girls continued living in notable dwellings in the same neighborhood. From left to right are Cora Belle, who died in her 20s, Catherine Helena (Mrs. C. Frank Lighton), Mable Louise (Mrs. Charles C. Wickwire Sr.), and Carrie Maude (Mrs. Edwin Duffy and later Mrs. Archibald Freeman). The surviving sisters were known for their charitable donations to their community.

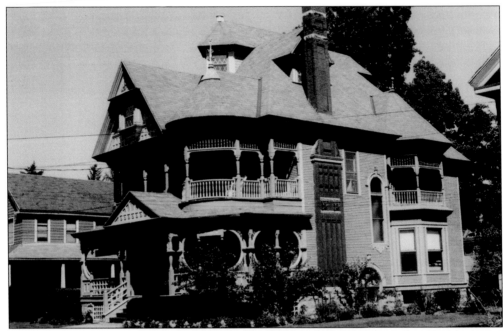

This remarkable house at 27 North Church Street is the result of mail-order architecture practiced by a company from Knoxville, Tennessee. It was built around 1896 for William J. Greenman, president of Cortland Door and Window Screen Company, by John Ireland, whose lumberyard adjoined Greenman's land, and his carpenter, John Harrison. Approaching from the west and south, its detail is apparent, while from the other directions the house is relatively bare.

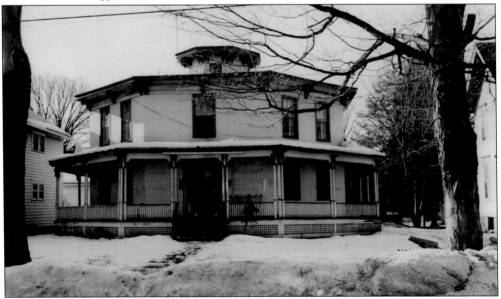

The city's only octagon house was built in 1855 by 40-year-old farmer William Burnham. He owned all the land from Grant Street to Clinton Avenue between Charles and North Church Streets. The rooms are square or oblong, and the corners held cupboards or closets. The porch at 14 North Church Street has been gone more than 50 years, and the residence has been converted to apartments.

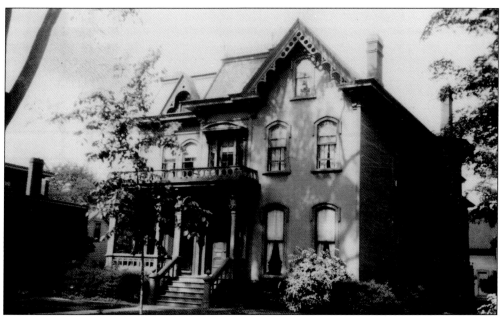

By 1892, 18 Church Street was the home of David F. Wallace. A smaller version of the Wallace block remains at the northwest corner of Main and West Court Streets. From there, he expanded his wallpaper business into the Hitchcock Wagon Company factory on Elm Street at the tracks. He also founded the Forging Company. His house once was Beard Funeral Home and now has dental offices and apartments.

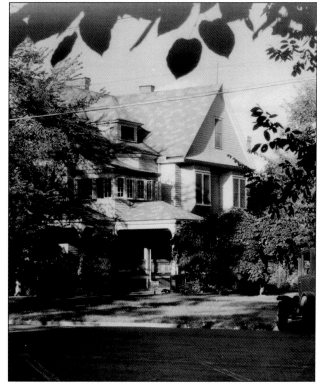

Dr. Francis J. Cheney moved into this home at 45 Church Street in 1891, when he was appointed the new principal of the normal school. Its Queen Anne turret was removed long ago. Following Cheney's death in 1912, many prominent families lived here. In 1928, it became the Arethusa Sorority. Twenty years later, a fire poured smoke throughout, resulting in the death of three young women.

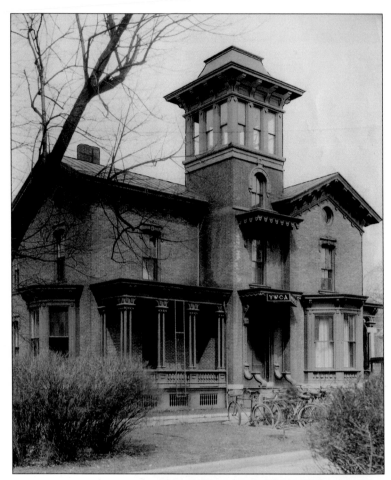

William (Billie) P. Randall was the son of Roswell Randall, and in 1869 he built his home facing Main Street on family land. His income was from his stagecoach business to Syracuse and Binghamton. His first two wives died young, and his third wife was the widow of the son of the county's leading abolitionist, which was a decided political twist. The property became the Young Women's Christian Association's in 1919.

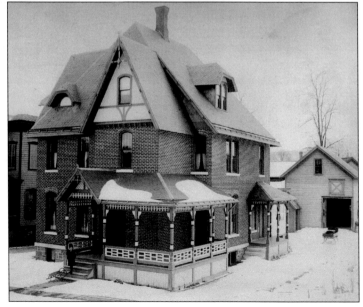

C. Frederick Thompson's brick home at 23 Clayton Avenue appears to be new. Local bricks were made at a yard on Clinton Avenue. The carriage barn has a pocket door, much more functional than the usual type. Although it has a modern appearance, that seems to be an outhouse to the left of the barn. Grocery store owner Thompson served on the village council, representing Ward One.

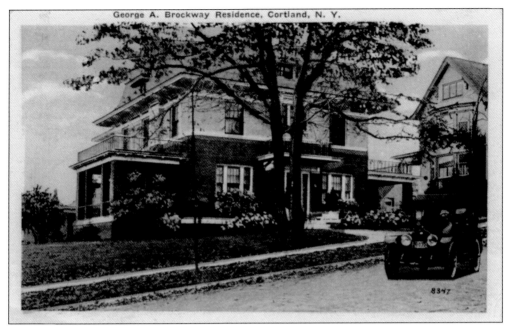

The south side of West Court Street was slow to home-building when George Brockway, a Homerite, decided on a Cortland home in the 1920s. Brockway's close neighbor was the deteriorating Randall house on Main Street, which Brockway had purchased with the hope of convincing the city to install a parking lot in the 1930s. A city referendum in 1935 to save the Randall mansion failed to pass.

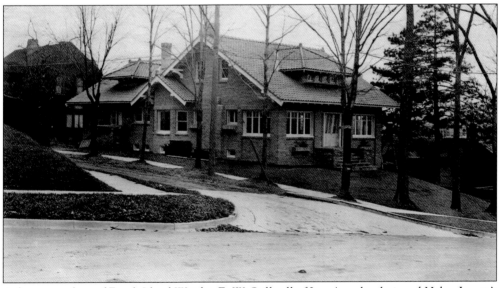

A former student of Frank Lloyd Wright, E. W. Stillwell of Los Angeles designed Helen Jewett's 1919 bungalow at 26 West Court Street. The bungalow had three levels that included 21 rooms and a three-tiered garden based on the Japanese symbolism of earth, man, and heaven. In 1921, Jewett opened her shop to sell Far Eastern handicrafts and art that she traveled the world to collect.

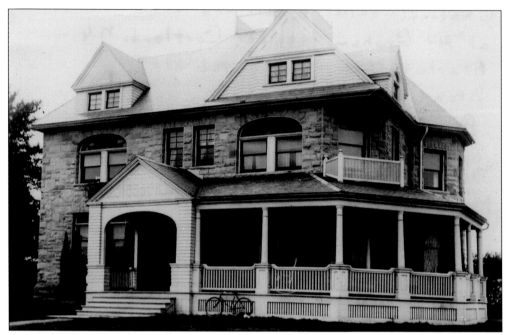

In 1885, brothers John Seaman Bull and Charles Sheldon Bull began the two-year construction of their Ohio stone home at 44 Graham Avenue. John was instrumental in organizing the Second National Bank, Water Works, and the elite Tioughnioga Club. Both were the last owners of the Glen Haven Hotel on Skaneateles Lake, which they sold to Syracuse in 1911. The Bull home was the normal school's principal's residence from 1923, and it was razed in the 1950s.

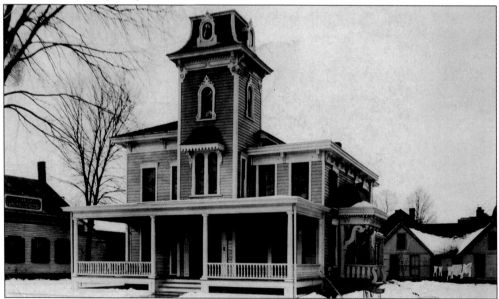

Elwyn R. Wright arrived in 1899. He refitted the house and stables at 16 Groton Avenue, built a large extension to the home, and opened an undertaking and livery business. His ambulance, hearse, and carriages were drawn by teams of black horses. Wright's son, Earl (shown shoveling snow), moved the business to 9 Lincoln Avenue. New York Telephone bought and built on 16 Groton Avenue.

It is unlikely that 172 Groton Avenue today resembles in any way the original erected by Moses Hopkins around 1810. Hopkins arrived from Massachusetts in 1794 and built the area's first frame barn in 1799, where it is said the first town meeting was held. It became kindling during the cyclone of 1922. In the 1940s remodeling of the house, four fireplaces were claimed to have been removed.

One of the last of the early settler homes still standing in the city is 192 Groton Avenue. Built around 1820 by Israel Van Hoesen, it is a one-and-a-half-story vernacular that has maintained pioneer characteristics, including a brick fireplace with a baking oven at the side and broad oak floorboards. The last available well water for thirsty travellers between Cortland and the village of Groton Village was located here.

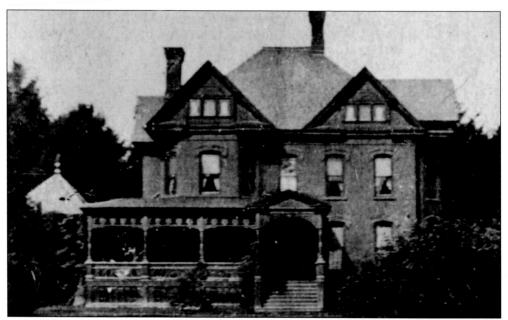

The Copeland-Boynton residence, built in 1887 at the corner of West Main Street and Homer Avenue, was unique for its final use as part of the 1911 hospital. Designed by Archimedes Russell of Syracuse, it sat on 5 acres and was made of pressed brick with a 12-foot veranda and a slate roof. There were 26 rooms supported by iron columns resting on heavy stone. There was also a six-horse stable, a cow barn, and a henhouse.

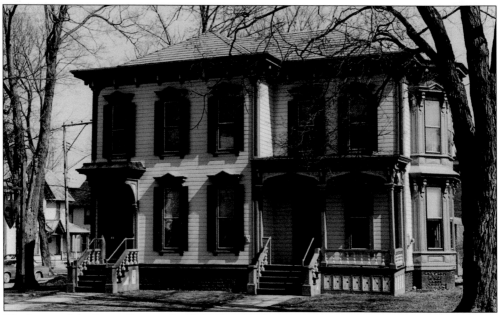

The home of the James Suggett family was at 25 Homer Avenue and is now the location of the Cortland County Historical Society's Suggett House Museum. Constructed in 1882 in Italianate style, it was built around a house already on the lot. The Suggett property included where Parker School, Suggett Park, and Wickwire Pool are today. The western part of Madison Street was originally Suggett Street.

Horace Dibble came through Cortland in 1821, saw a mill used as a nail factory, and thought that one day he would like to own the place on the creek. In 1833, he did, and he carded wool there for over 50 years. Owners of the Dibble home at 90 North Main Street after 1931 were the Bentleys, Moores, and Donald Ames, each adding to the character of the home.

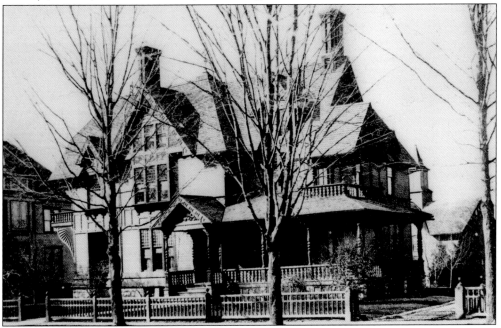

Large homes with intricately detailed porches were typical of the residences being erected by successful businessmen in this section of North Main Street in the 1880s and 1890s. Alexander Mahan's sale of musical instruments from 11 Court Street and his annual music festival at the Opera House provided seed money for 91 North Main Street. Following his death in 1905, the N. Jay Pecks called it home for some 30 years.

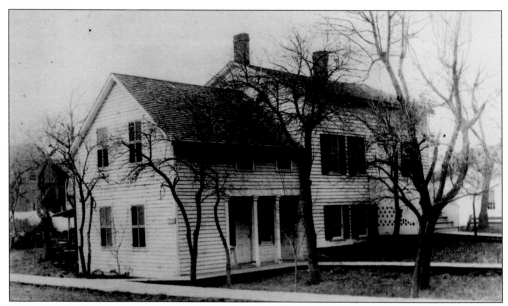

This country farmhouse with its Greek Revival porch was Ezra Rood's home on the northwest corner of Main and Madison Streets. The 1876 atlas of Cortland County shows that his farm extended west only to Schermerhorn Street (now Grace Street) and north to what became Arthur Avenue. Farm lots had been laid out for potential sale. In the early 1920s, this house was replaced by a gas station.

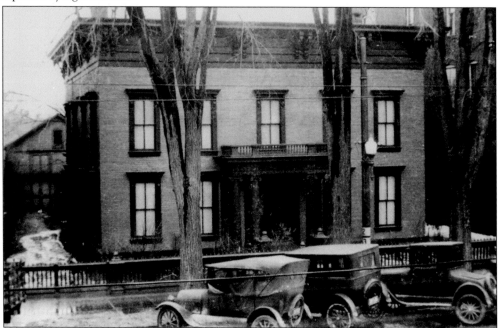

The last private residence in Cortland's principal business district, the Chadbourne house, was replaced by a building at 11–15 Main Street and was leased to W. T. Grant Company in 1937. The house was thought to have been constructed in the 1830s and was owned over time by Thomas Keator, who established the 1863 First National Bank. Mrs. Emily Chadbourne had been a Keator.

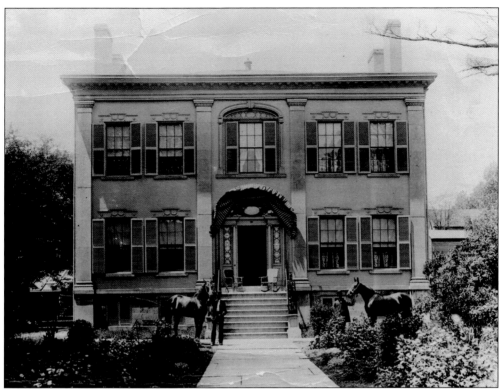

William Randall first constructed a home on Tompkins Street facing Main Street in the 1820s; it became his brother Roswell's home, and 100 years later, the home was converted to the Masonic temple with a replacement front on Clayton Avenue. In 1828, Randall constructed this house just north of the first and enhanced its Empire style with a greenhouse and with a summerhouse, which is now displayed at the Genesee Country Museum.

William's entry hall suggests the elegance of his home's furnishings, which were auctioned prior to the 1941 destruction of the building. A portion of the graceful staircase and a fireplace would find a new location at 7 Reynolds Avenue. The well house, a large garden urn, and part of the property's Main Street wall survive in the county, while the wrought iron gates greet guests at 29 Tompkins Street.

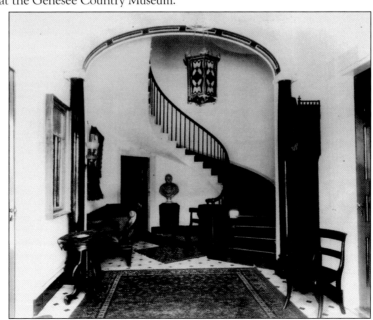

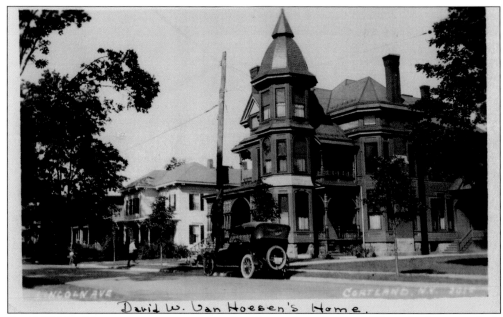

David W. Van Hoesen was as interesting as his Queen Anne home at 8 Lincoln Avenue, which today is unrecognizable since its conversion into a brick apartment building. A local organizer of the Little York Ice Company and owner of the summerhouse on Song Lake's island, he moved to Idaho in 1918 to operate a massive apple orchard. He died in 1923 while serving as an Idaho state senator.

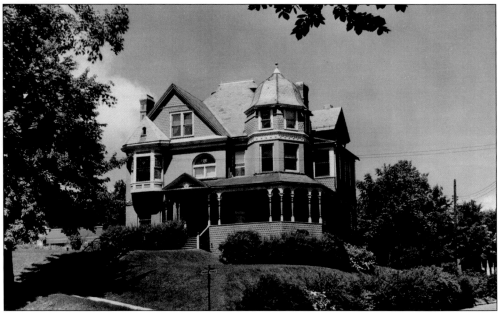

A brick Queen Anne, 15 Prospect Terrace was constructed in the 1880s and occupied by the Keese family before it relocated to California around 1900. Subsequently it was the home of Lightons and Millers. In 1927, the Agonian Fraternity (later Sigma Rho Sigma) purchased the property for $35,000. Later it housed Alpha Kappa Phi sorority, and today it continues as an address for college students.

On a private road, this cobblestone house was the home of Henry Randall's sheep farm's manager. Henry raised merino sheep and wrote *The Practical Shepherd*, the main source of information for farmers worldwide, which was illustrated by Francis B. Carpenter. Henry, a son of Roswell, drafted part of the 1867 wool tariff concerning the quality of wool imports. His farmland extended in the city to the area of Starr Road.

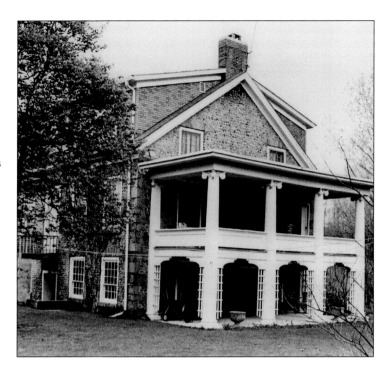

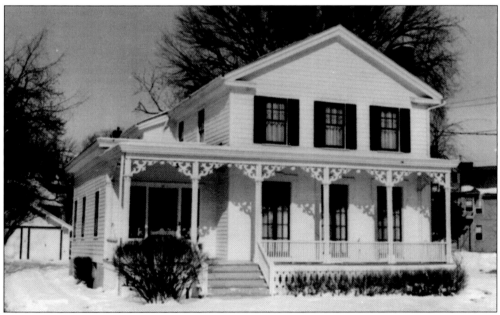

Henry Randall's father built 18 Tompkins Street as his wedding gift to his son in 1834. Constructed of clapboard, a characteristic of first decades of the 19th century, few external changes have taken place. The porch is Greek Revival, but no railing would have existed. Henry authored his work on sheep and a three-volume biography on Thomas Jefferson, the only one that included interviews with the subject's family, at the Tompkins Street house.

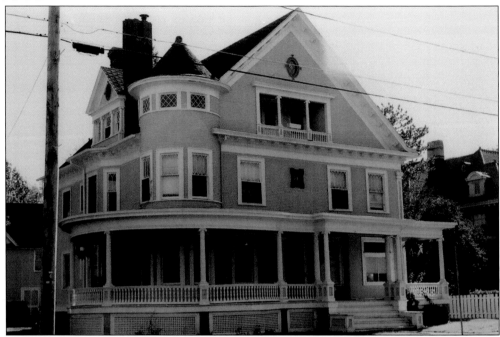

Previously, 23 Tompkins was always a dark color, likely as this reflected more of the masculine influence in its construction and design. This house was also apparently a wedding gift in 1897 for Garry E. Chambers's much younger bride. The interior has been known for its use of wood. Chambers was struck by a car in 1919 and died at age 80. His wife died in 1933 at age 72.

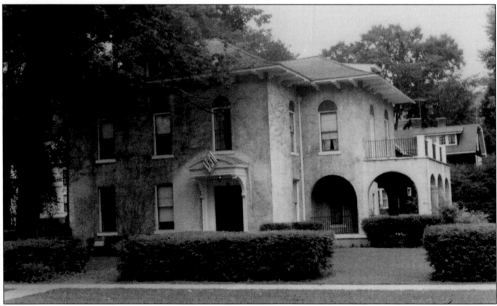

The house at 36 Tompkins Street began as brick in 1897 with a hip roof. G. Harry Garrison changed this in the late 1920s, as he covered the building with stucco and changed the roof. Garrison's career with the Homer Cortland Traction Company began as a relief driver and conductor in 1892 on its horse railroad. In 1928, he became president of the company, which eventually became part of Niagara Mohawk.

The city's first urban renewal attempts on Tompkins Street had homes torn down or moved. This 1870 house of Dr. Miles Goodyear was changed completely when moved to 41 West Court Street to give the new location more yard room. Dr. Goodyear was an 1816 graduate of Yale School of Medicine and the first Cortland doctor to qualify as an M.D. At age 70, he left to serve during the Civil War.

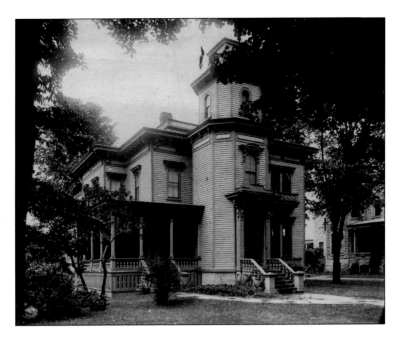

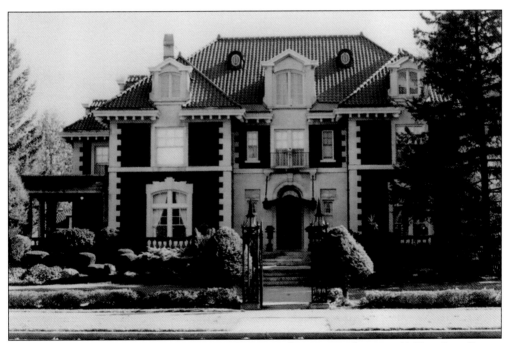

Pierce and Bickford of Elmira designed Charles C. Wickwire's 1912 house at 29 Tompkins Street. Its interior square footage far exceeds that of the street's other mansions. Its style is of English and French influence with a tile roof and a glass marquee. A sunroom was added in 1947. The house stayed in the Wickwire family until Charles Gibson purchased it in 1992; its 1.6 acres are now Alumni House property.

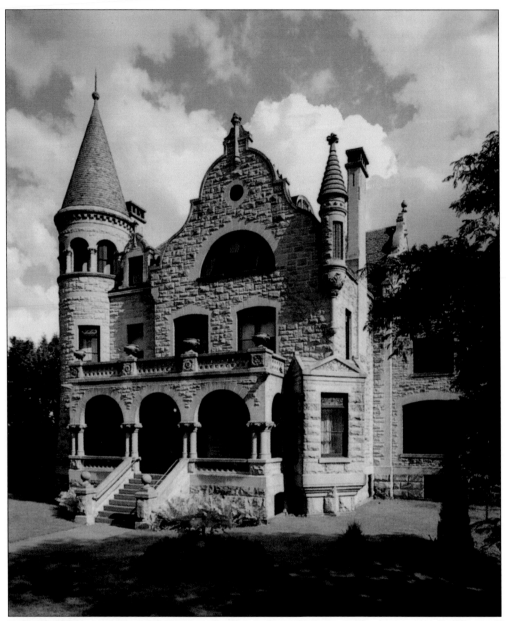

Before building at 37 Tompkins Street, the Hewitt home was moved back onto Argyle Place, off south Main Street. Chester Wickwire's family moved here in 1890. It is noted for its candlesnuffer tower tops, the fernery with its spectacular stained glass, which was added to the south side in 1925, and the handsome main stairway. The same year, Chester's widow, Mariam, had the front portico enlarged. A game room and ballroom are at the top of the east tower at the end of a narrow staircase. Upkeep on such a remarkable house necessitated that the Landmark Society of Cortland County become its owner in 1974. Intended to become an arts center for groups such as the cultural center, it instead became the 1890 House Museum. Efforts to preserve its period look are carried out even in the summer garden motif, which limits the use of flowering plants. However, the interior used color and flowers, such as in Mariam Wickwire's morning room next to the master bedroom. The property's carriage house is also worthy of attention.

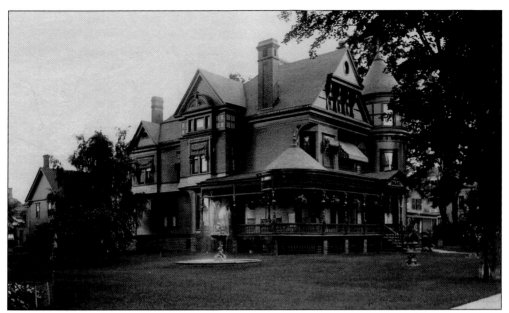

Lawrence J. Fitzgerald erected this example of the Queen Anne style in 1885 at 39 Tompkins Street at the peak of his career as owner of the world-renowned Cortland Wagon Company. Former president of the village and state treasurer for two terms, he is credited with casting the deciding ballot giving Grover Cleveland the state's delegation, which in turn gave Cleveland the nomination for president in 1884.

The Fitzgerald entrance hall reveals the pressed tin ceiling and beautiful use of woodwork. The stairs to the second floor are not fully apparent. Parlors are on each side, and the last door on the left, lead to the dining room. Maude Fitzgerald Duffy Freeman lived in the house until her death at age 89 in 1961. She always kept the house in admirable condition. Today it is a sorority.

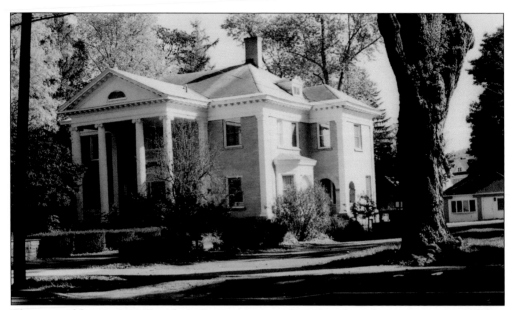

The original house at 41 Tompkins Street was moved south a short distance to accommodate this *c.* 1902 Frank J. Peck home. Made of buff pressed brick, it was constructed by J. D. Keeler of Cortland with the stonework done by Cortland's Beers and Warfield. Peck was a National Bank director and treasurer at the time of the construction. The Halsteads followed. Their canning company owned farms on Tompkins Street beyond the railroad tracks.

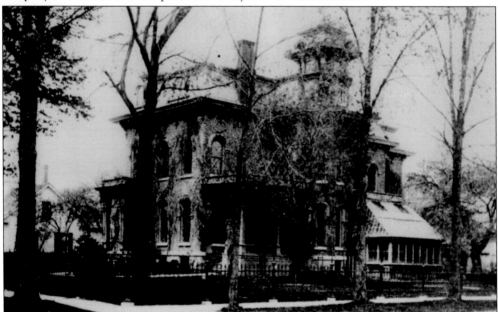

This 1891 photograph is of the James S. Squires home, built in 1871 at 44 Tompkins Street. Retiring from banking, Squires developed housing on the south side of the village on streets near factories and the Lehigh Railroad. In 1900, Nathan Miller, governor of the state in 1919, moved into the deceased Squires's home. In 1938, the house was torn down, and the bricks were reused in building the present house. The bricks were reversed, so that what is seen is the inside of the outside.

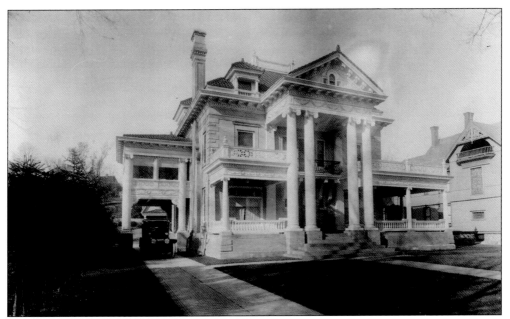

Edward Hill Brewer developed his father's harness business into the Cortland Carriage Goods Company, which evolved from buggy and carriage hardware to manufacturing automobile parts. He built the Palms, a 21-room frame home in Winter Park, Florida, in 1899 and constructed this 50 Tompkins Street mansion in 1905–1906. In 1923, he renovated the Florida house as a replica of the one in Cortland.

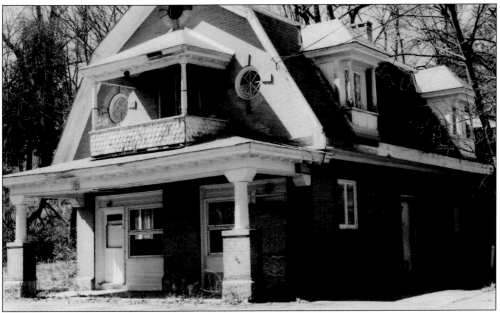

When building in 1906, the Brewers no longer needed to have a house for a horse. What was needed was a house for automobiles and possibly for servants as well. The Florida property would go to a federal government auction of the Palms in 1987 after it was seized from a drug smuggler. In 1989, arson ended 50 Tompkins Street, then a fraternity. Privately owned student housing was the replacement in Cortland.

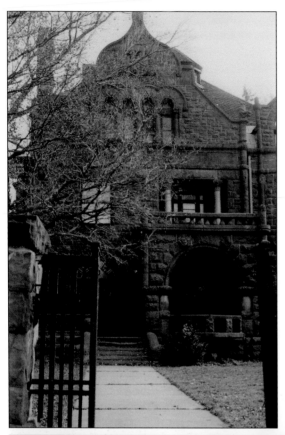

Theodore Wickwire, cofounder of the Wickwire firm, built this hand-cut brownstone in 1891 at 55 Tompkins Street after tearing down Judge Joseph Reynold's 1839 cobblestone and Greek Revival house. The new residence featured an elegant stairway and a playroom with a small stage. The property sold in 1935 for $15,000. It has since been a dormitory, offices, sorority with a live-in ghost, and apartments.

Jere Wickwire, son of Theodore, was a nationally recognized artist. He discovered an 1810 house in shambles along the Cherry Valley Turnpike, paid $50, and had its significant parts moved to property in the rear of his father's house at 7 Reynolds Avenue in the 1930s. Reassembled and viewed from the front, it appears as it did originally. The interior, however, was arranged to suit a 20th-century lifestyle.

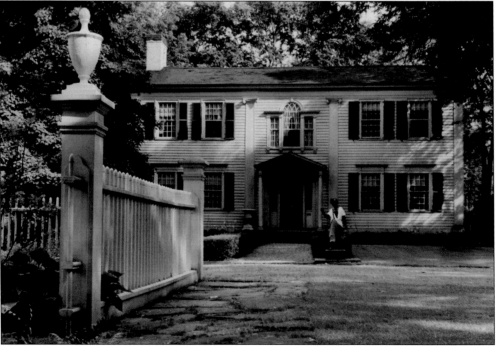

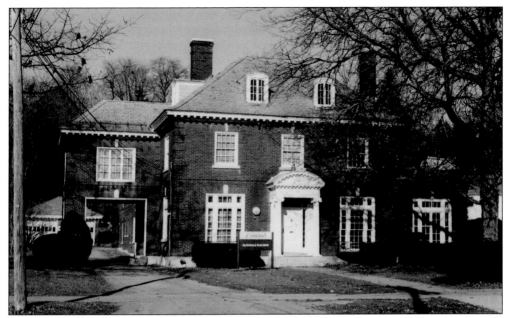

The redbrick building at 60 Tompkins Street was built for Robert Brewer in 1918 and is an early Carl Clark city design. In later years, it was the home of James M. McDonald, formerly of J. C. Penney's national offices and McDonald Crocker Farms. McDonald's foundation, at his death, gave the property to the college with $100,000; both to be used for inpatient and outpatient medical care.

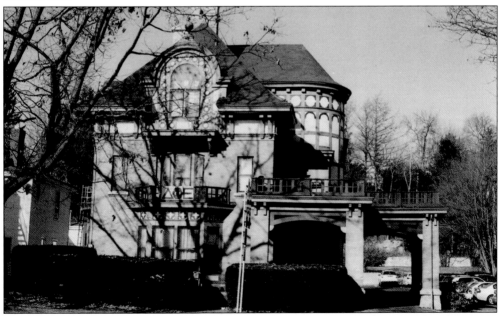

Theodore Wickwire constructed the house at 64 Tompkins Street for his son, Theodore Jr., in 1904. The son's preference to work for his father in the Buffalo area meant a short stay here. His brother, Jere, lived there until 1910. He was followed by Arthur Stilson, whose mother had been a Wickwire. The entrance hall's size is most impressive. In 1949, Arethusa Sorority moved in. It is now another sorority.

This large home with a mansard roof at 73 Tompkins Street has generally been known as the Rowley house. Nathan Rowley was a Revolutionary War veteran from Falmouth, Massachusetts, who pioneered in Cortland in the 1820s. His son, Nathan, had a daughter, Ardele, who married a VanBergen. Nathan Jr.'s wife, Carolyn, and Ardele's daughter, Florence VanBergen, passed away in this home.

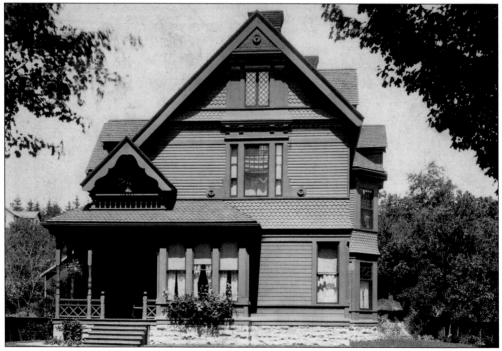

From its shingled siding to its dormered sleeping porch, this 1890s home at 78 Tompkins Street combines an array of architectural details. Catherine Helena Fitzgerald and C. Frank Lighton were united in a spectacular wedding at 39 Tompkins Street, moved to Syracuse, and returned when he entered the manufacture and sale of cigars. She died at age 94 in 1961, and a daughter lived here until her death in 1974.

Six

ON THE EDGE

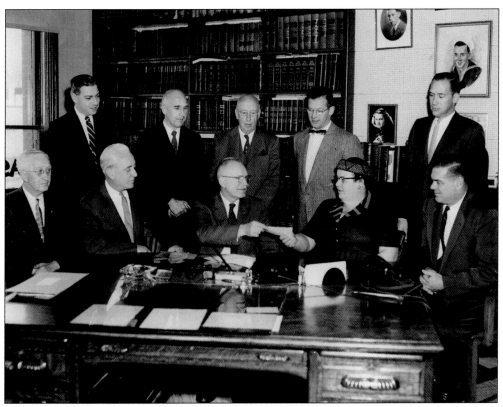

Cortland's Industrial Development Corporation worked with widowed Agnes Rorapaugh to sell 100 acres of her farm for $100,000 to Smith Corona. The company felt that was too high, so M. Cady Hulbert suggested a deal whereby 600 available acres could be purchased for $300,000. Smith Corona opened its new plant in 1960 and sold some of its extra land to a mall for more than the cost of it all.

The first tourist camp, with 25 units, was developed in 1930 on Route 11 between Cortland and Homer. The plans were to plant 100 shade trees and to have electric lights, running water, and heat in each cabin and showers and a kitchen in a community building. It suffered through World War II's gasoline rationing, flooding from the adjacent river, and the construction of Route 81. A motel now claims the site.

The need for automobile fuel in convenient places grew in the 1920s. This Spot Oil Company gasoline station was located on Homer Avenue's extension, which ran west of today's viaduct between Cortland and Homer and was close to the tourist camp. Following World War II, a plethora of stations opened throughout the city, and they have since been converted to beauty parlors, law offices, and ice cream parlors, among others.

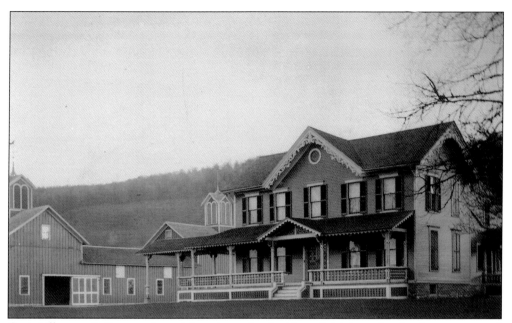

Orris Ullmann Kellogg graduated from law school with such high grades that he was excused from taking the bar exam. During his 65 years as an attorney, he built his Riverside Farms on today's Kellogg Road into one of the nation's foremost breeders of Holstein-Friesian cattle. He bred racehorses that trained on his farm's track. His home, his manager's home, and barns were showplaces.

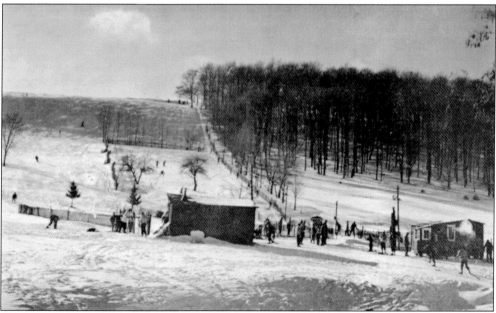

Coasting had been a major winter sport in the city. Sleds and toboggans would fly down Court Street Hill, through a closed section of Main Street, with a goal of making it to Church Street. Locust Avenue and any hillock was an attraction for the devotees. In 1947, the Cortland Ski Club introduced its ski run, Snowcrest, on Page Green Road, and people embraced this new winter speed choice.

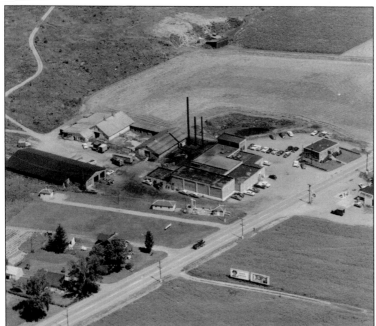

As soon as the Camp family completed construction of their meat packing plant on Route 281 (the finally paved "back road"), they needed to convert to producing products for the war effort, for this was 1941. What remains today is the small rectangular brick office building to the right on the road, a store for a longtime business, the Cortland Line Company.

A forested retreat for local Boy Scouts on Blue Creek Road was under development around 1930. Practical experience in the outdoors was easily accessible on the edge of the city. A ranger was employed in its early stages to assist Scouts and keep the rising cabins safe from vandalism. Seven troops built cabins according to their own whims. The St. Mary's Troop's resembled a typical 1930s house.

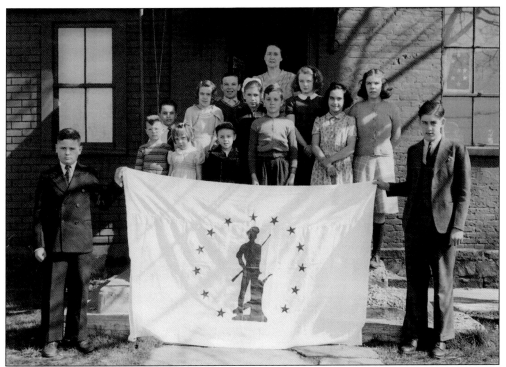

The Red Brick Schoolhouse at the northeast corner of Route 281 and Groton Avenue, dating to 1803, received this flag from the county's War Bond Committee in 1943. The school's 14 students sold $2,250.25 in war bonds and stamps. The eight stars on the window banner represent alumni in World War II. The state's department of transportation erased the school as a traffic hazard.

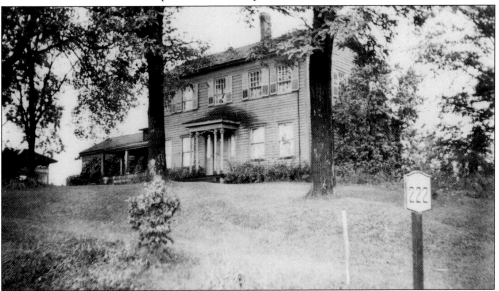

The northwest corner of Route 281 and Groton Avenue (Route 222) has become a mecca for chain drugstores. This home was destroyed in the 1980s by a dried Christmas tree igniting roof shingles after being put into the house's fireplace. For more than 100 years, its twelve-over-eight lights observed an active community at the crossroads when Dry Creek was a sizable stream.

George Brockway became a gentleman farmer on Route 281 with his Willow Brook retreat. He raised prizewinning Ayreshire cattle, which were housed in yellow stone barns, and entertained out-of-town dealers and children from the Munson Corner's School in a picture-perfect setting. Now, across the four-lane highway, the farm manager's house still stands on a rise, while a hotel entertains its guests along the lost creek.

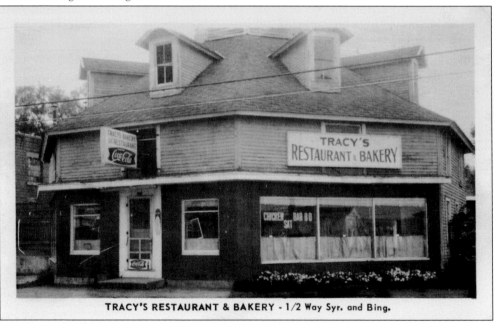

TRACY'S RESTAURANT & BAKERY - 1/2 Way Syr. and Bing.

Not far north of the Spot gas station and the Riverside Cabins on Route 11 north, dining was available at Tracy's. Installing plate glass windows opened up the former training ring of the Sig Sautelle Circus animals. The octagon shape, to replicate a big tent, has been a landmark since 1902. The restaurant, a long-term occupant with its chicken barbecue, was next to the Newton Line Company.

120

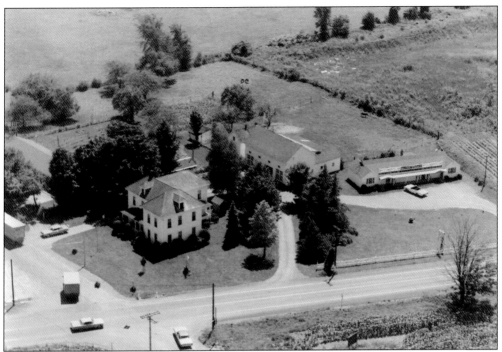

L. Ray Alexander was the district manager for the farm cooperative Grange League Federation (GLF), which became Agway and was located at the corner of McLean Road and Route 281. His memberships in agricultural organizations provided for a busy retirement, but in the late 1950s to early 1960s, he opened a small motel with a swimming pool behind his home. The beautiful house disappeared with the recent state highway improvements.

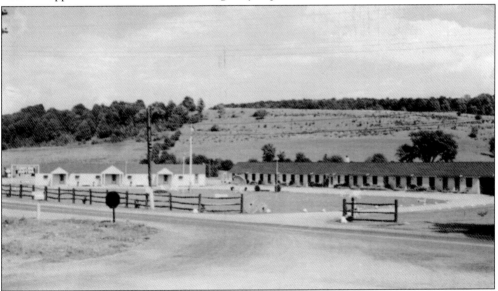

With its 18 units, the Cortland Motor Court was built back from the highway where Routes 281 and 13 meet. It supplied hot-water heat, private baths, television in each room, and cross ventilation. There was really no competition nearby for traffic headed south to Ithaca, perhaps, but the court was usually filled during important college events due to a scarcity of accommodations elsewhere.

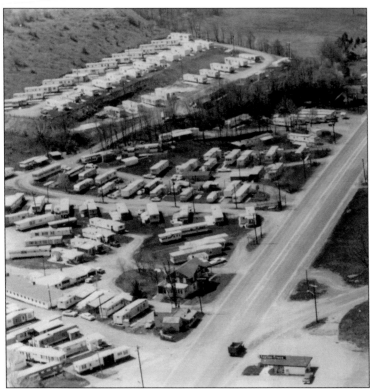

Cradled in an abandoned 1800s quarry at Munson's Corners, the Penquin-Starr Trailer Court reflects the affordable housing shortage in the city after World War II. After barracks life, having one's own space was important. By 1964, conversion of more Starr Road property for this purpose, however, brought about regulating ordinances. At one time, children from a nearby one-room school lunched on wild strawberries here.

This Dutch gambrel-roofed barn can be found at Starr and Page Green Roads. It was once part of one of the Frank Taylor farms and is perhaps the largest barn on the edge of the city, reminding one of the earliest roots of our community. The land dates to Roswell Randall, who sold it to his son Henry in 1839 for his merino sheep experiments.

The James McDonald Crocker farm was on East River Road. Peacocks were lodged behind high wire at one end of the property, and turkeys ran amuck at the toot of a car horn at the other. To the east were two cemeteries, but in between, on the north side of a barn, was another burial place. Engraved footstones marked the burial plots of prizewinning, moneymaking Guernsey bulls.

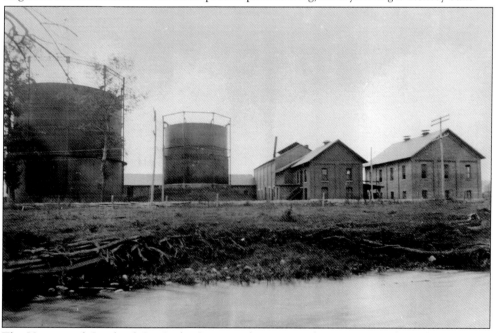

The Homer and Cortland Gas Light Company began providing service in the village in 1860. This facility on Route 11, between Cortland and Homer, was built to manufacture coal gas and by 1928 was producing 600,000 cubic feet per day for 15,000 customers in these two communities. It was owned then by the New York State Electric and Gas Company.

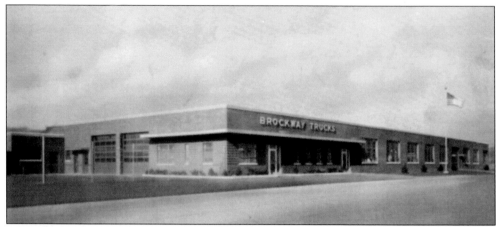

Natural gas was introduced locally in 1932, bringing an end to the coal gas complex. Sitting idle encouraged vandalism to the tanks, an unsightly situation. Finally, in 1944, the gas plant was put up for auction and was purchased by the Brockway Motor Company for $20,500. Long after the tanks were taken down, the smell of gas was evident while just driving by. Brockway constructed a building for sales and service.

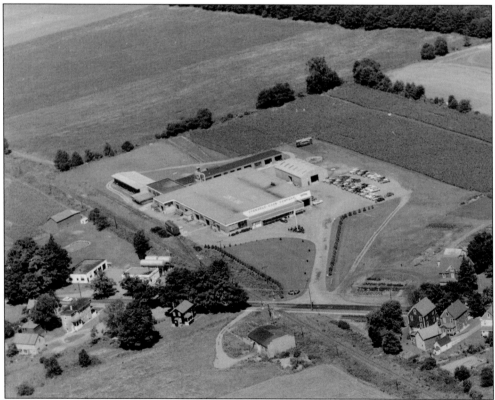

Overhead Door Company arrived in Cortland in 1929 at the former Edlund Plant at 65–69 Huntington Street. In 1948, the company built a modern plant at 200 Tompkins Street, and in 1965, the one pictured was constructed. It is now the Pall Trinity Micro Corporation. Manufacturing of doors ceased in the city in 1982, but sales and service continue on East Court Street. Note Route 281.

In 1974, a Belarus model farm tractor that was manufactured in Russia was being marketed in the county by a Syracuse dealer. George O'Dell, of Cortland, was promoting them and expected to have 40 dealers in New York soon. The first one to be delivered in the United States was by O'Dell to Oren Pendell (seated), a dealer in Lisle, New York. This was a new idea that had short-lived popularity.

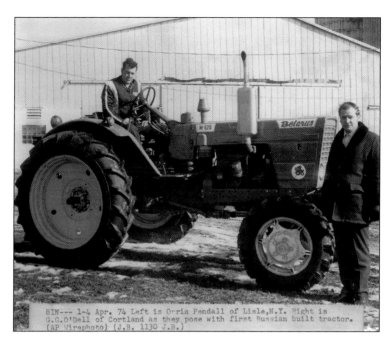

BIN--- 1-4 Apr. 74 Left is Orrin Pendall of Lisle,N.Y. Right is
G.C.O'Dell of Cortland as they pose with first Russian built tractor.
(AP Wirephoto) (J.B. 1130 J.B.)

Edlund Machinery Company became a division of Monarch Machine Tool Company in South Cortland on Route 13 south. A 140,000-square-foot plant costing $2.1 million in 1967 hardly resembled any factory Cortland was used to. In 1979, a $2-million expansion was added, but its occupants often faltered. It is adjacent to the Finger Lakes East Business Park, from which it should benefit.

These billboard barns welcomed travelers from the west to Groton Avenue. Just west of Glenn Street, their position is now the asphalt lot for the present shopping center. Dating the photograph is difficult, but the advertising suggests early 1900s. All these businesses were in operation in 1904; Ames sold shoes until 1912. Fresh driveway cuts implies the possibility of land being sold for new homes.

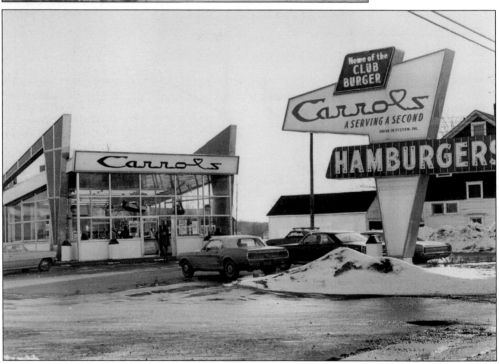

In July 1959, ground was broken on Groton Avenue farmland for what would become Cortland's first shopping mall, some distance behind the curbside Carroll's. Among the shops were Franconia's, an art and office supplier; a dress store; and two supermarkets. One of the supermarkets was lost to a fire in January 1975, when a battery charger on a portable floor polisher malfunctioned to the tune of $1 million.

A. B. Brown was an innovative approach to large-scale, department-store shopping. The barn had been a seller of agricultural equipment for some time, but in 1947, it was paired with a 10,000-square-foot, five-story building displaying goods behind massive plate glass and on an interior balcony. A 400-car parking lot indicated expectations of an exceptional number of customers.

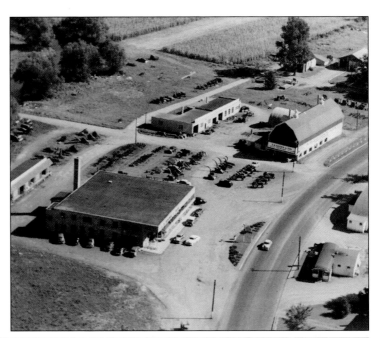

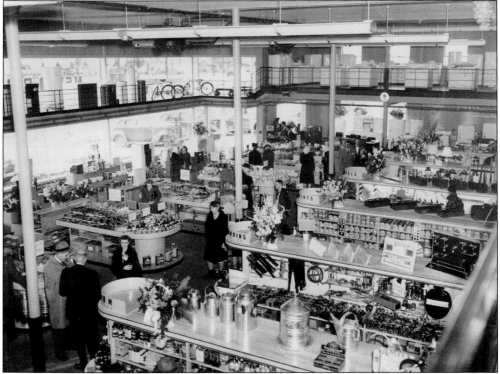

Opening just before Christmas, A. B. Brown's eight departments were overflowing with offerings in appliances, housewares, sporting goods, tools and building equipment, paint, farm supplies, and hardware. Their neighbors on Route 11, just north of the viaduct, were Skateland (for roller-skating) and a diner that later would be moved west. Brown's closed in 1998, making way for a potential museum for Brockways, tractors, military, and railroad artifacts.

www.arcadiapublishing.com

Discover books about the town where you grew up, the cities where your friends and families live, the town where your parents met, or even that retirement spot you've been dreaming about. Our Web site provides history lovers with exclusive deals, advanced notification about new titles, e-mail alerts of author events, and much more.

MADE IN THE

Arcadia Publishing, the leading local history publisher in the United States, is committed to making history accessible and meaningful through publishing books that celebrate and preserve the heritage of America's people and places. Consistent with our mission to preserve history on a local level, this book was printed in South Carolina on American-made paper and manufactured entirely in the United States.

This book carries the accredited Forest Stewardship Council (FSC) label and is printed on 100 percent FSC-certified paper. Products carrying the FSC label are independently certified to assure consumers that they come from forests that are managed to meet the social, economic, and ecological needs of present and future generations.

FSC

Mixed Sources
Product group from well-managed forests and other controlled sources

Cert no. SW-COC-001530
www.fsc.org
© 1996 Forest Stewardship Council

Find Your Place in History.